Flower Artists of Kew

Flower Artists of Kew

Botanical paintings by contemporary artists

William T. Stearn

The Herbert Press *in association with*
The Royal Botanic Gardens, Kew

The author wishes in particular to thank
Mrs Valerie Walley at The Royal Botanic Gardens,
Kew, for her enthusiastic co-operation in the
production of this book, and his wife, Eldwyth Ruth,
for her critical survey of text and proofs.

Copyright © 1990 The Herbert Press
Copyright in the individual paintings as listed on p. 157

First published in Great Britain 1990 by
The Herbert Press, an imprint of A&C Black (Publishers) Ltd
35 Bedford Row, London WC1R 4JH
in association with the Royal Botanic Gardens, Kew

Reprinted 1997

Artistic adviser: Mary Grierson
Research: Valerie Walley
Selection panel: Brinsley Burbidge, Mary Grierson,
David Herbert, Valerie Walley

Designed by Pauline Harrison
House editor: Brenda Herbert

Set in Baskerville Text by
Butler & Tanner Ltd
Printed and bound in Hong Kong by
South China Printing Co. (1988) Ltd

British Library Cataloguing in Publication Data
Flower artists of Kew: botanical paintings by
contemporary artists.
 1. Paintings. Special subjects: Flowers
 I. Stearn, William T. (William Thomas)
 II. Royal Botanic Gardens, Kew
 758.42

ISBN 1-871569-16-8

JACKET FRONT: *Iris susiana* by Margaret Stones

JACKET BACK: *Passiflora mollisima* by Mary Grierson

Contents

Foreword

THE YEAR 1990 celebrates both the 150th anniversary of the opening of the Royal Botanic Gardens, Kew to visitors and the arrival at Kew of Walter Hood Fitch, the most prolific and one of the most accomplished of all botanical artists. Even at that early date, 1840, *Curtis's Botanical Magazine*, now known as *The Kew Magazine*, which Fitch was to illustrate for some 40 years, was already fifty years old. Fitch was brought to Kew from Glasgow by Sir William Hooker, the first official Director and no mean illustrator himself. Between them they established, at Kew, a tradition of botanical illustration which not only continues to this day but is now in the midst of a remarkable development.

Botanical illustration has never been better served than it now is by many artists of quite exceptional talent, a considerable number of whom have connections with Kew. As a consequence, the selection of artists for inclusion in this book, which displays work from this development, has not been easy. Mary Grierson, Kew's official botanical artist from 1960 to 1972, has ably guided a small selection team whose first criterion was that the artist must, at some time, have painted either for Kew or for *The Kew Magazine*. Beyond that, excellence in serving the need for botanical accuracy while maintaining creative integrity was the team's sole guide in selecting from the paintings submitted by the artists themselves as most representative of their work.

Due to lack of space we have had to exclude some talented artists and some who, with great modesty, wished to be excluded but we have, I believe, achieved a well-balanced selection.

I am delighted that the Herbert Press has chosen to support one of the aims of Kew and its Gallery to bring to a wider audience the work of so many gifted painters who serve both science and art.

BRINSLEY BURBIDGE
*Head of Information and Exhibitions
at the Royal Botanic Garden, Kew.*

Botanical Illustration Ancient and Modern

BOTANICAL ILLUSTRATION is the portrayal of plants with enough accuracy and relevant detail for a particular kind to be recognized thereby and distinguished from other kinds. A less familiar use of botanical illustration is to demonstrate special or minute plant structures as an aid to their better understanding; of this the highly informative precise line drawings by Martin Zahn in the morphological works of Wilhelm Troll (1897–1978) provide model examples. A didactic sophisticated blending of art and scholarship, botanical illustration has primarily to meet the needs of science, but the hands of its greatest masters, notably Franz Bauer (1758–1840), his brother Ferdinand Bauer (1760–1826) and Pierre-Joseph Redouté (1759–1840), have created pictures which, while satisfying such needs, also stand as aesthetic masterpieces timeless in their quality. Differences of intent and technique rather than artistic skill distinguish botanical portraits from flowerpieces in which flowers are depicted primarily for aesthetic effect. This applies to the flowerpieces meticulously portraying gorgeous crowded bouquets by the great 17th-century Netherlands flower painters such as Ambrosius Bosschaert, Jan Breughel the Elder, Rachel Ruysch, Jan van Huysum and Pieter Casteels. It likewise applies to the flowerpieces with impressionistically painted roses, lilacs, etc. by the great 19th-century French artists such as François Lepage, Edouard Manet, Henri Fantin-Latour, Paul Cézanne, Claude Monet and Auguste Renoir. They all loved flowers but, unlike botanical artists, they saw them above all as components of an artistic creation. The flower painter fails if a work lacks beauty, the botanical artist fails if it lacks accuracy. Redouté achieved both in his multitudinous botanical portraits and in his flowerpieces. It is of interest that the Kew botanic garden provided him and Franz Bauer with plants to draw and paint.

The origin of botanical art, like botany itself, is to be found in the history of medicine, with special reference to pharmacology among the Ancient Greeks. The modern artists associated with the Royal Botanic Gardens, Kew inherit traditions directly linked to the illustrators of herbals, books primarily devoted to medicinal plants, in the 16th century. The portrayal of medicinal

plants, however, goes back far beyond that, to the 1st century AD at least. One cannot set the work of the Kew botanical artists in its historical setting as a continuation of a long tradition of service, originally to medicine, later to botany and horticulture, without looking backwards to its beginnings and development.

Illustrated Greek herbals and their medieval successors

KNOWLEDGE AND USE of selected plants for remedial purposes began long before recorded history, being part of the cultural traditions of literate and non-literate peoples the world over. This traditional knowledge passed from generation to generation by word of mouth from master to pupil. Plants can be edible, healing, poisonous or hallucinogenic: it may be literally a matter of life or death to know which is which. Hence people with such knowledge, shamans, witch-doctors and physicians, from time immemorial, have occupied a privileged position within their respective societies. Among the Ancient Greeks there arose medical practitioners who committed to writing the herb-lore which otherwise had to be memorized. This may well have been due to an increase in the number of plants considered to have medicinal virtues as a result of Hellenistic and Roman military campaigns and trading from the time of Alexander the Great (356 to 323 BC) onwards, which made known exotic drug plants and stimulated enquiry into others. Moreover medical men frequently travelled and so extended their knowledge of plants, notably the army doctor and herbalist Pedanios Dioscorides (1st century AD) of Anazarbos, Cilicia, Asia Minor.

The earliest herbal mentioned in Greek literature was compiled by Diocles (Diokles) of Carystus on the island of Euboea (Evvia) in the 4th century BC, but this work and its predecessors and immediate successors have not survived. Laboriously copied and hence existing probably in few copies, they were doomed to disappearance, but not, however, before parts of their works had been incorporated into the works of others. Thus the German scholar Max Wellmann in 1889 noted so many parallel passages in the Latin encyclopaedic work of Pliny the Elder and the Greek herbal of Dioscorides, both of the 1st century AD, which must have come from an earlier common source, the long-lost herbal of Sextius Niger. Although the herbal of Dioscorides, *Peri hules iatrikos*, is the only one which has survived in its entirety, it was by no means the only one available in the first century AD. In his preface

8

Dioscorides refers, usually somewhat critically, to the works of several writers, all of whom have passed into oblivion except Crateuas.

Nothing is known about contemporary illustrations to any of these herbals except that of Crateuas (Krateuas). After mentioning Greek writers on medicine, Pliny the Elder stated that 'Of these Cratevas, Dionysius and Metrodorus used a most pleasing method ... for they painted portraits of herbs and wrote their properties beneath.' If this drawing of plants had been common practice Pliny would not have specially mentioned these three exponents; moreover he referred to the difficulty of using it. Crateuas alone of the three has achieved lasting renown; indeed the historian of medicine and science Charles Singer described him in 1927 as 'the father of botanical illustration'.

Crateuas was the medical attendant to King Mithridates VI Eupator, known as Mithridates the Great (120 to 63 BC), the enemy of Rome who for a period ruled most of Asia Minor and had an extensive knowledge of poisons. The generic names *Crateva* (Capparaceae) and *Eupatorium* (Compositae) commemorate them in modern botany. References to Crateuas by Dioscorides, Pliny and Galen indicate that his works were available to Greek and Latin writers on medicinal plants down to the second century AD but only fragments of his *Rhizotomikon* survive. In the year AD 512 a splendid codex on vellum of Dioscorides' herbal was made at Constantinople as a present to the Princess Juliana Anicia. The text is elegantly written and embellished with illustrations in colour from at least three sources of varying merit which no longer exist. This codex, preserved in the Österreichische National Bibliothek and now called *Codex Aniciae Iulianae nunc Vindobonensis* or simply *Codex Vindobonensis*, was known to 16th-century herbalists as *Codex Caesareus* or *Codex Constantinopolitanus*. Its major interest lies in its numerous coloured illustrations of Mediterranean plants which have been superbly reproduced in a facsimile (published at Graz, 1966–70) made from the renovated original. A few sheets have been lost during its eventful history but reduced copies of these missing illustrations, made in 1350 when the codex was still complete, exist in the Dioscoridean *Codex Patavinus* at the Seminario Vescovile, Padua.

Some of the illustrations in the *Codex Vindobonensis* have been so corrupted in the process of copying from manuscript to manuscript over many years that they cannot be even plausibly identified; e.g. *Stroughion* (C.V. 294 verso), *Kuklaminos hetera* (C.V. 165 verso), *Muos oton* (C.V. 230 verso). *Gentiane* (C.V. 95 recto), *Apsinthion* (C.V. 22 verso). Others portray plants so faithfully that they can be identified with certainty e.g. *Erebinthos* (C.V. 119 verso; *Cicer*

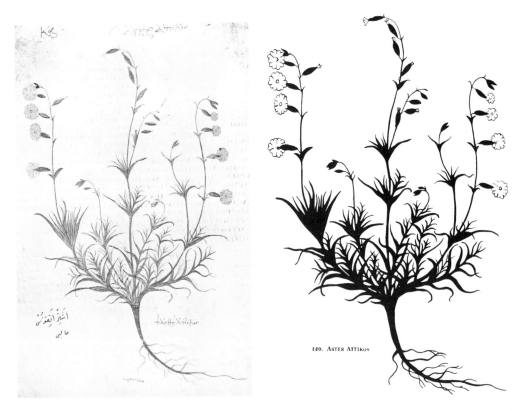

Fig. 1 *Silene linifolia* (Drawing copied and reduced from *Codex Vindobonensis* 32v.; reproduced from Gunther, *Greek Herbal*, 1934)

arietinum), *Aster attikos* (C.V. 32 verso, *Silene linifolia*), *Phusalis* (C.V. 359 verso; *Physalis alkekengi*).

Charles Singer believed, as Wellmann did, that these naturalistic illustrations had originated in the lost herbal of Crateuas. He stated that in Constantinople 'at the date of the Juliana Anicia Codex, naturalistic drawing had long been a lost art ... The Byzantine artist was utterly incapable of representing a living plant, save by slavishly copying an older drawing. All draughtsmanship of the fifth and sixth centuries goes to show that these naturalistic figures of the Juliana Anicia are not original ... The style of the best of these drawings shows that they date back to originals which can hardly be later than the second century AD and may be much earlier.' (Singer, 1927). Whether correctly associated with Crateuas or not, they reveal that an artist of antiquity looked at plants with an enquiring interest essentially the same as that of his modern counterpart and portrayed them as faithfully in accordance with needs and standards of a far distant past.

For many centuries this was not so. There were medieval scholars with

a genuine first-hand knowledge of plants, for example Wahlafrid Strabo (809–49) of Reichenau, Albertus Magnus (1193–1280) of Regensburg and his contemporary Rufinus of Genoa, but their writings lacked illustrations. A conscientious medieval scribe could both understand and faithfully transcribe a religious, diplomatic or legal document: the copying, however, of an illustration of something with which he was unfamiliar, e.g. a medicinal plant, demanded an artistic skill and interest which few possessed. Much-copied illustrations, originally not very good, ultimately bore little or no likeness to anything that had ever existed. Some compete for unreality with Edward Lear's humorous nonsensical botany. Their degeneration is obvious in the crude and worthless figures of the *Herbarium Apulei Platonici* printed by J. P. de Lignamine at Rome in 1481 from a 9th-century manuscript at Monte Cassino, southern Italy; a facsimile, produced for historical interest, not for the humanitarian but misguided purpose which inspired Lignamine, was published at Milan in 1979. This work was an anachronism even at the time of original publication in 1481.

At Padua in northern Italy, probably about 1400, an unknown artist had already painted illustrations of plants directly from nature for a herbal seemingly commissioned by Francesco Novello da Carrara (1359–1409), the last ruler of independent Padua before its seizure by the Republic of Venice. This herbal, known as the *Erbario Carrarese*, is now in the British Library, London (Egerton MS. 2020). Its numerous coloured illustrations depict plants accurately and in lifelike style. Moreover they possess several striking features, as noted by Hulton and Smith (1979): 'the artist's innate sense of design in relation to the page of written text; the quality of the figures themselves drawn with great economy and with a most sensitive line; the understanding of the form and habit of each plant which is clearly based on the artist's unusual powers of observation.' These are the very qualities which characterize the best modern botanical illustration as manifested in the present volume by artists associated with Kew. The *Erbario Carrarese* represents its beginning, a rebirth after many lapsed centuries of the Greek portrayal of living plants in a lifelike manner attributed to Crateuas.

The *Erbario Carrarese* was the forerunner of a much more extensive north Italian illustrated manuscript herbal, usually known as *Codex Rinio* but also designated *Codex Roccabonella*, in the Biblioteca Marciana, Venice. A Venetian artist Andrea Amadio provided the illustrations, nearly 500, almost all painted from living plants but a few copied from the *Erbario Carrarese*; both herbals are of the same high naturalistic quality. Scholars date its compilation as 1419.

The preparation of these two herbals with naturalistic illustrations must not be considered an isolated happening but rather as an initial manifestation of the general Renaissance tendency towards direct observation of nature which culminated in the flower studies of Leonardo da Vinci (1452–1519; cf. Emboden, 1987) and Albrecht Dürer (1471–1528) towards the end of the 15th century and early in the 16th. Exquisite little accurately portrayed flowers, often with some religious significance, decorate the borders of many 15th-century Books of Hours. About the middle of the 15th century a scribe wrote out the French text of a medieval Latin herbal, *Liber de simplici medicina*, leaving spaces in his manuscript, now known as *Livre des Simples médecines* (*Codex Bruxellensis* IV. 1024; cf. Opsomer & Stearn, 1984), for the insertion of illustrations. As in the *Codex Vindobonensis*, the coloured illustrations obviously come from different sources; the unevenness of treatment and differences in the colouring indicate that several artists contributed them. Those which give it special interest are about forty plants depicted with such accuracy and skill that the artist must have had actual plants under his eyes; about sixty more can be identified with little or no difficulty. Others can only be described as fictitious. As stated elsewhere (Stearn, 1984: 47), 'drawings of plants brought together from diverse sources to illustrate a single work invariably display much variation in skill of portrayal and degree of detail and this is particularly marked when they have originated in different centuries ... Thus the *Codex Bruxellensis* by the naturalness of some illustrations and the fictitious character of most stands between medieval uncritical copying and renaissance direct observation.' In time and character it marks the transition from the one to the other, the end of the manuscript tradition and the advent of the new art of printing, which greatly stimulated botanical illustration.

Botanical illustration by woodcuts

THE MAJOR DRAWBACK to the illustrated manuscript herbal was the difficulty of maintaining faithfulness of copied illustrations to their originals, as Pliny was aware. The invention of printing in the mid 15th century and the later extensive use of woodcuts for the reproduction of illustrations in black and white, which could be coloured by hand if desired, made it possible to reproduce any number of identical copies in a short time and at relatively low cost. The transcription of a manuscript on the other hand was a slow and costly process. Printing led in the 16th century to the development

of herbals with newly made naturalistic illustrations and with text based on fresh observations. It facilitated the international sharing of information which had been so restricted in the Middle Ages but which is basic to the progress of science. It gradually emancipated herbalism, of which plant science is a development, from uncritical acceptance of past authorities. Exotic plants had been known formerly only from their imported products such as roots, seeds, gums and resins brought by traders. When more of the whole plant became available, it could be illustrated and made more generally known. First, however, came the 16th-century investigation of European medicinal plants, which began as a scholastic attempt to identify the plants recorded by the Ancient Greek and Roman herbalists, in particular Dioscorides, and resulted in the discovery of a multitude of plants unknown to them. To record these, illustrations were essential. The woodcut provided the means of publishing them at only one stage removed from the artist's original. But for the stimulus of this technique, botanical illustration would have remained static.

To make a woodcut illustration the object to be figured had first to be drawn on paper. Then the outline was transferred to a block of wood planed smooth. The wood itself was that of apple, pear, medlar or quince, all members of the *Rosaceae* subfamily *Pomoideae*, with tough fine-grained wood which planes to a very smooth surface; working along the grain a woodcarver then cut away the wood between and around the drawn outlines which in the end stood raised above the general surface of the wood block. This could then be locked into a frame called a 'chase', together with the type, the whole then put in the printing machine, inked and pressed by the machine on to paper; this took the impression of the raised outline on the wood block. Obviously the raised inked lines of wood had to be stout enough to withstand the printing pressure imposed upon them. The woodcut line, according to A. H. Church, is about 250 μm thick and too stout for illustrating organs less than 1 or 2 mm. That did not matter in the 16th century.

The first use of woodcuts to illustrate a large number of plants was in the *Herbarum vivae Eicones* (Strasbourg, 530) with text by Otho Brunfels (1488–1534) and illustrations by Hans Weiditz (Johannes Guidictius, b. before 1500, d. after 1535). These 'living pictures of herbs' are masterpieces of woodcut printing and, in a sense, excessively true to the specimens portrayed, for if they came to Weiditz in a wilted state, with the leaves flaccid or withered, so he drew them and so they accompanied Brunfels's text. As Arber (1938) has written, 'the notion had not then been grasped, that the drawing which

is ideal from the standpoint of systematic botany, avoids the accidental peculiarities of any individual specimen, seeking rather to portray the character fully typical for the species.' A few original coloured drawings by Weiditz have survived by being stuck into the herbarium of a Swiss physician Felix Platter (1536–1614); they were beautifully reproduced by Walther Rytz in 1936. From them one learns how much of artistic merit was necessarily lost on their conversion into woodcuts, excellent though these are. Weiditz's illustrations of, for example, *Symphytum officinale* and *Onopordum acanthium* are such as a modern artist could be proud to have painted.

Much better known for its woodcut illustrations is the herbal of Leonhart Fuchs (1501–1556), his Latin edition *De Historia Stirpium* (1542) being followed by a German edition *Neue Kreuterbuch* (1543) with the same illustrations. The text of the herbals of Brunfels and Fuchs has essentially a medieval character, being largely compiled from ancient authors. The originality of these herbals lies essentially in their illustrations, made from living plants. Whereas Weiditz provided illustrations of plants which were almost an embarrassment to Brunfels because, being natives of the Rhineland, they were unknown to classical authors and hence had no Latin names and were nomenclaturally 'naked', Fuchs's two artists, Heinrich Füllmaurer and Albert Meyer, and his woodcarver Veit Rudolph Speckle collaborated under his close supervision. Fuchs solved the problem presented by Brunfels's anonymous *herbae nudae* by coining new Latin-form names for them, e.g. *Digitalis* for foxglove (German *Fingerhut*), *Ophioglossum* for adder's tongue (German *Naterzünglin*), *Cruciata* for crosswort (German *Creutzwurtz*) and *Campanula* meaning 'little bell'. The accompanying illustrations established the application of these new names, all in modern botanical use; this remains an important function of botanical illustration. Although uneven in quality, the Fuchs woodcuts are highly decorative and were much admired by Ruskin and William Morris among many other connoisseurs of botanical art. For Agnes Arber, as also for the present writer, they 'represent the high-water mark of that type of botanical drawing which seeks to express the individual character and habit of each species, treating the plant broadly as a whole, and not laying more stress upon the reproductive than the vegetative organs.' Fuchs instructed his artists to avoid shading and the effectiveness of their work depends upon simple outline. A number of copies were issued with the illustrations coloured. Even more remarkable than the survival of a few original paintings by Hans Weiditz in the herbarium of Felix Platter is that of 1,538 original coloured illustrations made for Fuchs, both those of the

printed work and others intended for a continuation never published; these, having long been in private hands, were acquired by the Österreichische National Bibliothek, Vienna in 1954. In 1986 Siegmund Seybold published reproductions of those depicting orchids.

The herbals of Brunfels and Fuchs were the forerunners of numerous botanical books illustrated with woodcuts during the 16th century, of which the most impressive is the edition with large illustrations of the commentaries on Dioscorides by Pierandrea Mattioli (1501–1577); this edition was first published in 1562 with a Czech text, in 1565 with a Latin text. The illustrations, remarkable for filling the space available with masses of foliage, often elaborately shaded, were the work of Giorgio Liberale and Wolfgang Meyerpeck; a suprising number of the original woodblocks have survived. Whereas the works of Brunfels and Fuchs portrayed plants mostly native or cultivated around Strasbourg and Tübingen, Mattioli's coverage was much greater, since he had a wide range of correspondents who supplied him with materials. Among them were Ulisse Aldrovandi (1522–1605) at Bologna, Luca Ghini (1490–1556) at Bologna and Pisa, Jacopo Antonio Cortuso

Fig. 2 LEFT *Ficus carica*, Fig (Woodcut from Mattioli, *Herbarz ginak Bylinarz* 1562, as *Ficus*)
Fig. 3 RIGHT *Dryas octopetala* (Woodcut from Clusius, *Rariorum aliquot Stirpium*, 1583, as *Chamaedrys III*)

(d. 1603) at Padua and Conrad Gessner (1516–65) at Zürich. He also received plants native or cultivated in the eastern Balkan Peninsula and Asia Minor from the ambassador Ogier Ghislain Busbecq (1522–92) and his physician Willem Quackelbeen (1527–61). Mattioli lived in the horticulturally exciting period (roughly 1560–1620) notable for the introduction of hitherto unknown plants from the Near East, called by Gregor Kraus in 1894 'die Zeit der Orientalen', and many of these came into his hands. Among them were the lilac (*Syringa vulgaris*), the white horse-chestnut (*Aesculus hippocastanum*) and the garden tulip (*Tulipa gesneriana*).

Mattioli's work was followed by several works published by the Antwerp printer Christophe Plantin with woodcuts mostly based on illustrations by Pierre van der Borcht. Of these the most important botanically is *Rariorum Plantarum Historia* (1601) by Charles de l'Ecluse (Carolus Clusius; 1526–1609) wherein he gathered together the information he had collected on his travels in Spain, Hungary, Austria and elsewhere. One of the most versatile scholars of the 16th century, he was above all a master of plant description, noting in Latin the essential features of the multitude of new or little-known plants which came to his attention. The utility of his work owes much to the admirable little woodcuts illustrating all the species, just as George Bentham's *Handbook of the British Flora* 2nd edn (1865) owed much of its popularity to wood-engravings by the Kew artist Walter Hood Fitch (1817–92).

Copperplate etching and engraving

DURING THE 17TH CENTURY the engraved copperplate superseded the woodblock for botanical illustration and maintained its supremacy well into the 19th century until the lithographer's stone took over. Whereas in a woodcut the printing ink lies on raised ridges, in an etching or engraving the ink lies in furrows cut into a metal sheet, this being known as *intaglio* ('cut into'). For an engraving, the illustration is drawn on the thinly waxed surface of a polished copper plate with a tool (burin) having a sharp triangular end, which produces finer lines than is possible in a woodcut. Ink is rubbed into the furrows, filling them, and the excess ink on the surface is then wiped off, leaving it clean. For an etching the surface of the metal plate is coated with acid-resisting wax on which the illustration is drawn with an etching needle penetrating through the wax to the metal surface below. The lower side of the metal sheet is completely protected by coating it with an acid-resisting

substance. The plate is placed in a shallow bath of dilute acid, which bites into the lines not protected by the wax, which is later removed. This method was at first little used in botanical illustration, although Fabio Colonna (Fabius Columna; 1567–1650) adopted it for his *Phytobasanos* (1592) and *Ecphrasis* (1606–16).

The most impressive of works illustrated by engraved copperplates is the enormous *Hortus Eystettensis* (1613) by Basil Besler (1561–1629) of Nürnberg, fortunately completed and published before the outbreak in 1619 of what was to become the ruinous Thirty Years War. The Prince-Bishop of Eichstätt, Johann Conrad von Gemmingen (d. 1612), was a keen gardener and flower-lover and the garden at his episcopal residence became the most richly stocked in Europe, with over a thousand kinds, representing nearly 700 species. He put Besler, a Nürnberg apothecary, in charge and encouraged him to portray its plants; six engravers made the 374 plates. Most of these illustrate several often unrelated species on the same plate, put together because of a similar flowering season, although a few occupy an entire plate, e.g. *Hibiscus syriacus* 'Albus', *Nerium oleander*. Besler either had luxuriantly grown specimens of some plants or figured them larger than life which is more probable. There exist five sumptuously coloured copies: from one of these in Paris a facsimile of the plates was published in 1987 as *L'Herbier des quatre Saisons*. Since many garden forms are included, such a coloured copy provides the most complete record of plants in cultivation at the beginning of the 17th century.

This German work had a French sucessor in the *Mémoires pour servir á l'Histoire des Plantes* (1625–1701) edited by Dionys Dodart (1634–1707) for the Académie Royale des Sciences with superbly drawn illustrations mostly by Nicolas Robert (1614–85), one of the most esteemed of 17th-century botanical artists; they were finely engraved with meticulous attention to details of pubescence etc. by Abraham Bosse (1602–76) and Louis de Chatillon (1638–1734). Modern artists would do well to study them in the Department of Botany, British Museum (Natural History) or the Lindley Library of the Royal Horticultural Society in London.

By then more and more botanists had become convinced that sexuality comparable with that of animals existed in plants, the stamens being regarded as male organs, the pollen as spermatic, and the pistil or ovary as a female organ. This notion current among English botanists such as Thomas Millington, Nehemiah Grew and John Ray in the mid 17th century was proved experimentally by a German botanist Rudolph Jacob Camerarius (1665–1721) at the University of Tübingen; an account of his experiments and

conclusions, *De Sexu Plantarum*, published in 1694, had a profound and lasting effect upon botanical illustration. It directed attention especially to floral parts and led to the neglect of the underground organs, which, on account of their medicinal properties real or supposed, from the time of the Greek rhizotomists (literally 'root-cutters') such as Crateuas, had always been considered much more important and were generally portrayed in herbals.

A botanical artist influenced by this change of emphasis was Claude Aubriet (1665–1742), originally a miniaturist, who was employed by the French botanist Joseph Pitton de Tournefort (1656–1708) to illustrate his *Elémens de Botanique* (1694) and *Institutiones Rei Herbariae* (1700). Tournefort made his major contribution to botany by defining the genera of plants methodically and accurately; he based them primarily on the structure of the flowers and fruits. These parts Aubriet portrayed meticulously and thereby contributed greatly to the utility and influence of Tournefort's concepts. His series of engravings provided models for later illustrators. In March 1700 Tournefort, accompanied by a young German doctor, Andreas Gundelsheimer, and by Aubriet as draughtsman, set off on a two-year journey of enquiry to the Near East. They visited Crete and many Aegean islands, Constantinople (Istanbul), went by boat to Trebizond (Trabzon), travelled overland to Erzerum and then to Tiflis (Tiblisi). On the return journey they climbed Mount Ararat, later travelled across Asia Minor to Brusa (Bursa) and Smyrna (Izmir), returning by sea to Marseilles in April 1702. This remarkable journey provided Aubriet with material for many botanical and other drawings, some of which appeared in Tournefort's posthumous *Relation d'un Voyage au Levant* (1717). Later some appeared in 19th-century publications, Desfontaines' *Choix des Plantes* (1808) and Jaubert and Spach's *Illustrationes Plantarum Orientalium* (1842–57), all with fine engravings.

During the 18th century the Swedish naturalist Carl Linnaeus (1707–78) revolutionized the classification and naming of plants, uniting many genera which Tournefort had kept apart, as have indeed many later botanists, and providing them with more convenient names. His emphasis on the number of floral parts ensured that botanical artists thereafter followed Aubriet in portraying them. This has led to the elaborate illustration of dissected flowers in such Kew publications as *Hooker's Icones Plantarum*, the *Kew Bulletin* and *The Kew Magazine* and in many other taxonomic periodicals and books. Linnaeus's works relied on precision of terminology and only one has notable illustrations, his *Hortus Cliffortianus* (1738) with thirty-six engraved plates, which was produced in Holland. Dionysius Ehret (1708–70) drew twenty-

one of these plates when working in Holland for George Clifford, who was at the same time Linnaeus's patron. There began Ehret's rise to renown as one of the most prolific and skilled of 18th-century artists and engravers. He settled in England in 1836, married the sister-in-law of Philip Miller, Curator of the Chelsea Physic Garden, and thereafter never lacked interesting plants to paint. His highly decorative plant portraits adorn the works of his early patron the physician, botanist and bibliophile Christoph Jakob Trew (1695–1769) of Nürnberg, notably *Plantae selectae* (1750–73), which established his reputation internationally, *Hortus nitidissimus* (1750–86) and *Plantae rariores* (1764–84), as well as his own *Plantae et Papiliones rariores* (1748–62). He also contributed botanical illustrations to other publications. According to Gerta Calmann in her illustrated biography, *Ehret, Flower Painter extraordinary* (1973), more than 3,000 of Ehret's drawings are extant. Some of them were first published in 1971 by Averil Lysaght. These include twenty-three on vellum depicting dried speciments of plants collected by Joseph Banks (1743–1820) in Newfoundland and Labrador in 1766. Seemingly these are the first botanical drawings commissioned by Banks who later, as unofficial director of the Royal Gardens, Kew, initiated the employment of artists there to delineate its plants.

The Royal Botanic Gardens, Kew

IN 1751 the widowed Princess of Wales, Augusta of Saxe-Gotha, took charge of the Royal Garden at Kew, then a little Thameside village, and being fond of plants, as was her late husband Frederick, Prince of Wales, she founded in 1760 a 'Physic or Exotic Garden', evidently inspired by the one at Chelsea belonging to the Society of Apothecaries and in the charge of the great gardener, Philip Miller, who, being of Scottish origin, was reputed to employ only Scottish gardeners. In 1759 she engaged a Scotsman, William Aiton (1731–93), trained at Chelsea under Miller, to lay out nine acres as a botanic garden. By 1768, thanks to the skill of Aiton, the enthusiastic support of Princess Augusta and the advice of John Stuart, Earl of Bute, and the apothecary and botanist John Hill, the botanic garden had acquired 3,400 plants. When Augusta died in 1772, her Kew garden and adjacent land passed into the hands of her son King George III, to whom Banks and his companion Daniel Solander (1733–82) were introduced in August 1771.

Sir Joseph Banks

JOSEPH BANKS, who came early into a large fortune and the ownership of land in Lincolnshire, made his first acquaintance with botanical illustration as a schoolboy perusing John Gerard's *Herball*, probably Thomas Johnson's edition of 1633, with its numerous woodcuts. He certainly acquired a life-long appreciation of the value of good illustrations of plants. On his return from Newfoundland in 1766, he employed Ehret to portray specimens brought back. He travelled round the world with Captain Cook aboard the *Endeavour* in 1768 to 1771 at his own expense and took with him two artists, Alexander Buchan (d. 1769) and Sydney Parkinson (*c.* 1745–71) to record graphically the natural history and geography of the voyage. Parkinson, described by Cook as 'Mr Banks's botanic painter', who died prematurely on the homeward voyage, made about 952 drawings.

In New Zealand and eastern Australia the multitude of strange plants overwhelmed Parkinson. He lacked time to make complete drawings; a rapid sketch indicating the habit of growth, with position of leaves and flowers, a careful watercolour drawing of a leaf, a piece of stem and a flower, had to suffice as a record, from which, with the aid of dried specimens, a perfected illustration could be made on a later occasion; he also added notes on the colour. This is a good method to use for flowers that quickly fade or wither. Back in England a team of artists in Banks's employ, namely John Cleveley, John Frederick Miller, James Miller and Frederick Polydore Nodder, had to complete Parkinson's work. They made surprisingly beautiful and accurate pictures out of Parkinson's material. Banks intended to publish the botanical results of the *Endeavour* voyage in folio volumes with impressive engraved plates and the descriptive text in Latin by his botanist librarian the erudite Swedish naturalist Daniel Solander. The engraved plates had to be made from the completed drawings but Banks found it no easy task to assemble enough skilled engravers for such an exacting and slow task. They included Daniel MacKenzie, Gerard Sibelius brought from Holland, Gabriel Smith and Frederick Polydore Nodder and fourteen other obscure or lesser known engravers. In all they produce 753 engraved copperplates, from which proofs were taken. Wilfrid Blunt in 1950 wrote that 'the engravings are disagreeably mechanical', but some are elegant and graceful and almost all are masterpieces of engraving with perspective and texture indicated by intricate parallel and criss-crossing lines. Unfortunately all this costly effort came to

nothing in Banks's lifetime for reasons which can only be surmised. Among them must have been the death of Solander in 1782, the involvement of Banks in many other activities and the difficult economic situation caused by wars in America and Europe. Efforts to publish them in the 19th century did not succeed; prints from the actual surviving 738 copper plates have, however, been first published by the Lion and Unicorn Press in 1973, with text by Blunt and Stearn, and by Alecto Historical Editions in 1980–88. Although delay in publishing destroyed the scientific impact of Parkinson's illustrations and Solander's detailed text, they were available and used by scholars visiting Banks's Soho Square house, once the botanical centre of London, and later the British Museum, and then the British Museum (Natural History) to which they were transferred. Most of Parkinson's hitherto unpublished drawings of Fuegian plants have been used to illustrate so modern a botanical work as David M. Moore's *Flora of Tierra del Fuego* (1983), a testimony to the lasting utility of good botanical illustrations.

Banks, whose country house, Spring Grove, at Heston, Middlesex, was not far from Kew, succeeded the Earl of Bute as adviser to King George and ultimately became director of the Royal Garden in all but name. On 24 May 1791 he wrote to the Dutch scientist Martinus van Marum (1750–1837) that the time he had given to Kew had delayed the publication of the work on the plants of the *Endeavour* voyage and he further stated on 14 February 1792 that he had given much attention to preparation of coloured illustrations of plants at Kew. Banks had had this in mind for some years. His enthusiasm, enterprise and wealth led him to send collectors abroad to collect and introduce new plants, the first being a Scot, Francis Masson (1741–1806), despatched to South Africa in 1772. Thus he promoted an astonishing inflow into the Royal Garden of new plants deserving portrayal. In 1770 the Dutch-born Austrian botanist Nikolaus Joseph von Jacquin (1727–1817) had begun publication of a sumptuous folio work with hand-coloured copper-engravings of new or rare plants in the Vienna botanical garden, *Hortus botanicus Vindobonensis* (1770–76), followed by *Icones Plantarum rariorum* (1781–93). The artists he employed included two highly talented young men, Franz Andreas Bauer (1758–1840) and his brother Ferdinand Lucas Bauer (1760–1826), destined to become two of the greatest botanical artists of all time. Jacquin's work gave precedent for preparation of similar work on Kew plants, but for this Banks needed artists. James Sowerby (1757–1822) had already shown his capability by making 10 illustrations of plants for the French botanist C. L. L'Héritier de Brutelle in 1787 and others for *Curtis's Botanical Magazine* (1787),

but soon he became fully occupied in drawing British plants for *English Botany* (1790–1814). Banks had to look elsewhere: fortune played into his hands.

In 1788 young Joseph Franz Jacquin (1766–1839), the son of N.J. von Jacquin, came to London from Vienna bringing with him Franz Bauer. In 1789 he wrote to his father that Banks had his eye on Bauer. Banks, with his appreciation of talent, soon realized that Franz Bauer was the very man for the task he had in mind. He outlined this in a letter of 19 April 1788 to L'Héritier: 'We have a project here which I fancy will be speedily put into execution, to publish the plants as they flower at Kew in numbers, which mode we prefer to any other; as by that means, the publication will go on as long as it succeeds, and consequently an opportunity remains of inserting new things soon after their first appearance.'

Employment by Banks offered Franz Bauer financial security and ideal working conditions; in the multitude of plants of the Kew botanic garden he had an inexhaustible treasury of material for his art. He accepted the post of resident botanical artist at Kew, later given the designation 'Botanick Painter to His Majesty', and worked there happily painting whatever he pleased to the end of his days in 1840. Banks paid his salary and ensured that it continued to Bauer's death. The drawings which Bauer made when in Banks's employ were Banks's property and accordingly passed, through the Banks bequest, ultimately to the British Museum (Natural History); most of the drawings and papers left by Bauer at his death are in the University Library at Göttingen. Ernest Augustus (1771–1851), Duke of Cumberland, one of Queen Victoria's 'wicked uncles', during his long residence in Kew must have come to know Bauer well; he became the illiberal despotic King of Hanover, Ernst I, in 1837, acquired Bauer's legacy and presented it to Göttingen University in 1841 and 1842. Little, however, came of Banks's project, maybe owing to adverse economic conditions during the French Revolutionary and Napoleonic wars which much reduced his income. The only result, but a superb one, was *Delineations of exotick Plants cultivated in the Royal Garden at Kew* (3 fascicles, each with 10 engraved and coloured plates, 1796–1803) with the most beautiful, detailed and accurate illustrations of South African *Ericaceae* ever made.

Bauer became an expert microscopist and excelled in portraying the exquisite detail of, for example, pollen grains which his studies revealed. His interest in orchids culminated in his *Illustrations of Orchidaceous Plants* (1830–38) with lithographed plates, for which John Lindley, Britain's leading orchidologist, provided the text. He published *Strelitzia depicta or coloured Figures of*

the known Species of Strelitzia in 1818, one of the earliest English botanical works with hand-coloured lithographs. His drawings of ferns, redrawn for lithography by W. H. Fitch, provided 120 lithographs for W. J. Hooker's *Genera Filicum* (1838–42). Bauer was not the only Kew illustrator of plants. A Scottish gardener at Kew, Thomas Duncanson, from the Edinburgh Botanic Garden made about 300 drawings of Kew plants between 1822 and 1826 for the superintendent W. T. Aiton and another gardener, George Bond (d. 1892), made about 1,500 drawings between 1826 and 1835, when he became head gardener to the Earl of Powis. These Duncanson and Bond illustrations are a valuable record of plants grown at Kew, particularly of succulants associated with Adrian Hardy Haworth.

Although Banks's multitudinous wide-ranging beneficent activities left only a meagre amount of publication to his personal credit, he stands never-theless as the first great English promoter of botanical illustration. No-one before him employed and encouraged so many artists in the portrayal of plants. He initiated botanical illustration at Kew and lived in the finest period of the engraved plate as its medium. His friend William Jackson Hooker developed botanical illustration to greater service at Kew, but he had available the cheaper technique of lithography which only became known towards the end of Banks's life.

Banks realized that, to merit the name 'botanic garden', such a garden must be associated with research on plants. Hence, of the numerous botanic gardens in existence or founded early in the 19th century, only those survived which were linked to centres of botanical learning. There was no herbarium or library at Kew: his own at Soho Square took their place and his botanist librarians, successively Daniel Solander, Jonas Dryander and Robert Brown, devoted much of their time to identifying and describing the plants grown at Kew. These included many species new to science, which, as mentioned above, Banks wished to have portrayed. The results of the work of three botanists were published as *Hortus Kewensis* (3 vols. 1789) under the name of the Royal Gardener, William Aiton (1731–93), with thirteen copper engravings by Franz Bauer, G. D. Ehret, J. F. Miller, J. P. Nodder and James Sowerby; the second edition (5 vols, 1810–13) appeared under the name of his son, William Townsend Aiton (1766–1849), although neither Aiton could have compiled them.

Pierre-Joseph Redouté

Pierre-joseph redouté (1759–1840) is the best known of the great botanical artists, largely on account of the popularity of modern reproductions from *Les Roses* (3 vols, 1817–24), which gives the impression that he painted nothing but roses. In fact he illustrated a great diversity of plants, at least 1,800 species, notably succulents in *Plantarum Historia succulentarum* (1798–1837) and petaloid monocotyledons in *Les Liliacées* (8 vols, 1802–16) and many others in such works as *Jardin de la Malmaison* (2 vols, 1803–5) and *Choix des plus belles Fleurs* (1827–33). These works are botanically much more important than *Les Roses* on account of the many plants new to science they so pleasingly and accurately portray.

Born at Saint-Hubert in the Ardennes, Redouté belonged to a family of artists, with inherited artistic ability traceable back at least to his 17th-century great-grandfather, and manifested in his father and his two brothers, Antoine and Henri. Work in Holland as a young itinerant painter acquainted him with the gorgeous flowerpieces of the Dutch masters and he sought to emulate them in painting flowers. At the age of 23 he moved to Paris. Here he attracted the attention of an influential and wealthy French magistrate, bibliophile and botanist C. L. L'Héritier de Brutelle (1746–1800) and a celebrated Dutch artist Gérard van Spaendonck (1746–1822). Through them he came to devote his life to botanical illustration and flower painting. His patron L'Héritier dashed to England in September 1786 with botanical specimens he should not have taken out of France. In April 1787, at his request, Redouté came to England to draw new or little known plants grown in the Royal Botanic Garden at Kew and in other gardens of the London area. His work here provided 22 plates for L'Héritier's *Sertum Anglicum* (1788).

The most important outcome of this visit was his learning the craft of stipple engraving. Hitherto botanical illustrations had mostly used line engraving or etching, with criss-crossing lines variously spaced to represent shading. In stipple engraving this is achieved with greater ease and more subtly by engraved dots instead of lines. Redouté developed this method with great success, making colour prints from a single plate which had, however, to be inked anew for each colour. He was a supreme master of perspective, as is evident in his superb representations of succulent plants. He was, moreover, very fortunate in royal patronage, notably by the Empress Josephine, which enabled him to have his botanical art published in sumptuous folio

volumes, a privilege not available to many of his talented contemporary artists. These included some of the greatest botanical artists of all time and they equalled him in the accurate portrayal of minute detail, but not in popularity.

William Jackson Hooker and Walter Hood Fitch

WILLIAM JACKSON HOOKER (1785–1865) and John Lindley (1799–1865), a friend from youth onward, were both born and educated in Norwich, Norfolk, an important provincial botanical centre in the late 18th century and the home also of a leading botanist, one of the three founders of the Linnean Society, James Edward Smith (1759–1828), who was a friend of Banks. Smith provided the text for several finely illustrated works, notably Sowerby and Smith's *English Botany* (36 volumes, 1790–1814) with 2,592 octavo copper-engravings by James Sowerby, *A Specimen of the Botany of New Holland* (1793–95), with 54 quarto copper-engravings by James Sowerby, and Sibthorp and Smith's *Flora Graeca* vols 1–7 (1806–32). Hooker and Lindley were both taxonomic botanists and botanical artists of high merit, and a remarkable array of illustrated works stand to their credit. The lives of all three were strongly influenced by the encouragement of Banks, and two, Lindley and Hooker, ultimately and happily, were responsible for the achievement of his Kew ambition.

After education at the Norwich Grammar School, young Hooker devoted himself to natural history, having extensive private means. He found good friends among the many Norfolk naturalists, one being J. E. Smith, possessor of Linnaeus's collections and library, another Dawson Turner (1775–1858) of Yarmouth. The latter was a banker, a highly cultured and erudite man who collected books and manuscripts but was especially interested in mosses and seaweeds. For his *Fuci* (4 vols, 1807–19) Hooker drew 234 plates, having probably inherited artistic ability from his mother. People interested in botany and possessing some artistic talent on visiting Turner's house soon found themselves drawing seaweeds, but Hooker provided most of the illustrations for the *Fuci*, without, however, receiving any acknowledgement in the work itself. Turner proposed him in 1806 for election to the Linnean Society of London and, together with Smith and other Norfolk naturalists, gave him an introduction to Banks. Impressed by the obvious enthusiasm and ability of

Hooker, just 21, Banks permitted him to use his great library and herbarium. This interview led, indirectly, to Hooker's association with Kew.

Back in Norfolk, Hooker applied himself to providing illustrations of seaweeds for Turner and for a book of his own on mosses, *British Jungermanniae*, published in twenty-two parts between April 1812 and June 1816. A bryological classic, this is remarkable not only for the thoroughness with which Hooker investigated and described these minute plants but above all for his eighty-eight plates meticulously portraying them in greatly magnified detail. It is a forerunner of his great contribution to botanical illustration at Glasgow and his promotion of this at Kew. Meanwhile the inheritance of a large fortune allowed him to travel with Dawson Turner, then with William Borrer, a well-known amateur botanist, to the Highlands of Scotland, and in 1809, under the auspices of Banks, to Iceland. Unfortunately, on the return voyage, the ship loaded with tallow caught fire and, although all aboard were saved by another ship, all their possessions including Hooker's collections went up in flames. In 1811 he issued privately his *Journal of a Tour in Iceland in 1809*. A second edition commercially published appeared in 1813. In June 1815 he married Turner's eldest daughter, Maria (1797–1872), then aged 18, beautiful, charming, intelligent and well educated. Turner hoped that someday Hooker might succeed him as a bank manager and financier. Meanwhile Turner and his brother had acquired a brewery at Halesworth in Suffolk, which included a residence, and, with the best of intentions for Hooker's well-being and security, induced him to take a managerial share in it. His first child, William Dawson, was born at Halesworth in 1816, followed by Joseph Dalton in 1817 and daughters Maria, Elizabeth and Mary in 1819, 1820 and 1825. The brewery did not thrive as much as expected and Hooker, though astute, preferred botany to brewing. Luckily the professorship of botany at Glasgow became vacant in 1819 and, thanks to the support of Robert Brown and Sir Joseph Banks, Hooker was appointed in 1820. He had had no university education and, like Linnaeus and Lindley when they became professors, had never attended a university lecture. Nevertheless Hooker's enthusiasm, his profound self-acquired botanical knowledge, his eloquence, his skill in blackboard drawing, his Highland excursions with students and his promotion of the new Glasgow botanic garden into one of the best in Europe made him a very successful professor. He left Glasgow in 1841 to become director of the botanic garden at Kew.

During this Glasgow period of twenty-one years Hooker published a series of well-illustrated botanical works, among them *Exotic Flora* (1822–27),

Botanical Miscellany (1829–33), *Icones Filicum* (1827–32), *Flora Boreali-Americana* (1829–40) and a series of botanical periodicals, among them *Icones Plantarum* (1836 et seq.), with numerous illustrations by himself. In 1827 he began to edit, from vol. 54 onwards to vol. 90 (1864), *Curtis's Botanical Magazine*. To this likewise he contributed not only text but for almost ten years all the illustrations in which he included floral dissections. Ultimately thousands of illustrations of new and little-known plants appeared in the publications of Hooker and his son Joseph Hooker (1817–1911). They owed this astonishing output largely to the triumph of lithography over engraving and their employment, almost exploitation, of Walter Hood Fitch (1817–1892).

Lithography (named from Greek *lithŏs*, stone, *graphē*, writing, drawing) depends upon the antipathy of oil (or grease or wax) and water; even when mixed they separate into their kind. The inventor of this printing technique was a Bavarian playwright, Alois Senefelder (1771–1834), who made it known in 1798, its first application being for music printing. The design to be printed, before the introduction of zinc or aluminium plates, was drawn with a crayon of lamp-black and beeswax (or tallow) on a thin slab of finely ground and polished Bavarian limestone, the crayon filling its fine pores and repelling water which filled the other pores when damped. A roller with greasy printer's ink when passed over the damped stone slab leaves the ink only on the crayon design. This design is printed on to paper laid on the slab and pressed against it. The printed design consists of minute dots corresponding to the pores in the limestone slab. This represented a major departure from *relief* printing, as with woodcuts where the ink stands on ridges, and *intaglio* printing of engravings and etchings, where the ink rests in furrows, in that the ink is deposited on a flat surface. Lithography is accordingly called a *planographic* process. Later, plates of zinc or aluminium, with a mechanically prepared surface, have taken the place of limestone. This lithographic method was not only much cheaper and quicker than the earlier ones, it also enabled an adept artist such as Walter Hood Fitch to put his work directly onto the printing surface and permitted him all the gradations he wished. The first botanical work having lithographed and hand-coloured illustrations seems to be *Flora Monacensis* (4 vols, 1811–18) by Franz von Paula von Schrank (1747–1835), with 400 plates drawn and lithographed by J. N. Mayrhoffer (1764–1832), printed in Munich. Lithography granted artists the liberty of portraying plants with whatever complexity they desired.

Walter Hood Fitch, who ultimately had over 9,900 published botanical illustrations to his credit, became the supreme botanical exponent of lith-

ography. Born in Glasgow he was apprenticed as a pattern drawer to a Glasgow firm of calico printers but after his work in the factory he helped Hooker to mount herbarium specimens. Fitch's bold style of botanical draughtsmanship probably owed much to his apprenticeship. Hooker soon realized that in this industrious lad he had a potential artist for his own works and he bought him out of apprenticeship, instructed him in botany and botanical drawing and set him to produce illustrations for *Curtis's Botanical Magazine*. Fitch's first illustration, portraying *Mimulus roseus* (now *M. lewisii*), appeared in vol. 61: t. 3353 (1834). His contributions increased and for approaching forty years he was the *Botanical Magazine*'s sole artist, responsible for nearly 2,800 plates. His intimate acquaintance with living plants enabled him to draw herbarium specimens in life-like poses as vividly as if they had been living plants under his eyes. He acquired firsthand an extensive knowledge of floral diversity which he graphically revealed to the botanical and horticultural public.

Meanwhile John Lindley, the Norwich friend of Hooker's youth, had risen from a penurious beginning to become an important figure in British botany and horticulture, simultaneously a professor in the University of London, an editor, an international authority on Orchidaceae and an administrator of the Horticultural Society of London. Like Hooker he was a skilled botanical artist; like Hooker he was a self-taught botanist without a university education and degree. As with Hooker his publications had gained him a great international reputation; moreover he possessed a strong forceful personality. In 1838 the Treasury, anxious to rid itself of the burdensome Kew botanic garden, appointed a committee presumably intended to advocate its destruction. However it could not avoid appointing Lindley and Joseph Paxton, the Duke of Devonshire's highly esteemed head gardener, both men of independent judgement, as well as the probably more amenable J. Wilson, head gardener to the Earl of Surrey, the Lord Steward responsible for Kew. Their report was not what the Treasury wanted, certainly not to the liking of Lord Surrey who sought to have the Kew collection of Australian plants destroyed. Lindley, however, had circulated copies of his unpublished and suppressed report. It proposed that this private royal garden should be made the 'National Botanic Garden' and 'converted into a powerful means of promoting national science' or else abandoned. Public indignation at the proposed destruction of the garden resulted in its management being moved from the unfriendly Lord Steward's Department to the Commissioners of Woods and Forests. Lindley himself wanted the post of Director of the renewed

Royal Botanic Gardens, but Hooker wanted it even more. As academic conditions worsened for him in Glasgow, he longed for a move to the London area and had tried over several years, through correpondence with the public-spirited botanically minded 6th Duke of Bedford and then his son Lord Russell, to get the Kew appointment. Lindley, though championed by the Duke of Devonshire, stood down. In March 1841 Hooker, aged 56 and thus within four years of the present retiring age, was officially appointed Director of a run-down garden with no herbarium, no library, no laboratory, but with the immense botanical and horticultural potentialities envisaged by Lindley. When he died in 1865, still Director, he had made them realities.

Hooker brought to Kew not only his furniture, library and herbarium; he brought his artist W. H. Fitch. He continued to edit *Curtis's Botanical Magazine* but, with the development of the garden on his hands, he left more and more of the *Magazine*'s illustration to Fitch though he himself wrote the text. The Second Series of the *Magazine* ended with vol. 70 (1843–44) of the sequence as a whole. The plates until then had been engraved or etched. From volume 71 onwards Fitch both drew and lithographed the plates which, as before, were hand-coloured. Without Fitch's help the publication of the *Magazine* might have ended.

Fitch's services to botanical illustration extended far beyond the *Botanical Magazine* and *Hooker's Icones Plantarum*, to which he contributed about 485 plates, as Hemsley's account (1915) makes clear. He also provided litho-graphed plates for a number of impressive botanical works owing their present high prices to his superb illustrations rather than to their text, botanically important though that is. They include Joseph Dalton Hooker's *Botany of the Antarctic Voyage of H.M. discovery Ships Erebus and Terror* (6 vols, 1844–60), *The Rhododendrons of Sikkim-Himalaya* (1849–61) and *Illustrations of Himalayan Plants* (1855), and W. J. Hooker's *Niger Flora* (1849), *Victoria regia* (1851), *A Century of orchidaceous Plants* (1851), the plates taken from *Curtis's Botanical Magazine*, *A Century of Ferns* (1854), *Filices exoticae* (1857–59), *A second Century of Ferns* (1860–61) and *The British Ferns* (1861). Both the Hookers were among the most prolific and distinguished botanists of the 19th century but their influence would have been smaller, their publications less valued and used today, but for the wealth of clear and informative illustrations with which Fitch enriched them. Although he was the iconographic servant and at times the slave of the Hookers, others also sought his help to illustrate specialist and costly works; but Fitch's best known illustrations are the 1,295 little wood-engravings in the second edition (1865) of George Bentham's popular *Handbook of the British*

Flora. These were issued in a separate volume, with additional illustrations by Worthington George Smith (1853–1917), under the title *Illustrations of the British Flora* in 1880 and were continuously reprinted down to 1931. It became a hobby of lady botanists in Britain to colour these figures from living plants and accordingly to search for as many species as possible in a wild state. The *Illustrations* were supplemented in 1930 by R. W. Butcher and the artist Florence E. Strudwick's *Further Illustrations of British Plants.*

Aged 80, Hooker died in 1865, as did Lovell Reeve, publisher of *Curtis's Botanical Magazine,* and his botanical and horticultural friends Lindley and Paxton, all men of high ability, strong character and almost incredible industry and together responsible for the publication of an extraordinary number of illustrations of new and little known plants. His son Joseph, after voyaging with Ross on H.M.S. *Erebus* in 1839 to 1843 and travelling in Sikkim and eastern Nepal in 1847, became Assistant Director of the Royal Botanic Gardens, Kew in 1855. He succeeded his father as Director and paid a fitting tribute to him as the restorer of the gardens, first founder of a museum of economic botany, promoter of scientific enterprise in the British Colonies and much else. Joseph inherited his father's scientific ability and artistic talent but he lacked his tact, his patience with human beings. Often over-worked he could be arrogant, autocratic, overbearing and inconsiderate. Fitch continued to work for him in portraying plants for *Curtis's Botanical Magazine.* The drawings that Fitch made for the *Magazine* were placed in the Kew Herbarium and he was not adequately paid for them. He badly needed money to support his family, but never received an official salary as a Kew artist. Joseph Hooker was unsympathetic and unhelpful to his artist's plight. In May 1874, feeling desperate, Fitch stated in a letter to George Bentham: 'I have drawn for the Bot. Mag. without a hitch for nearly 40 years ... The drawbacks, the responsibilities and exactions I have had to endure since 1860 have given my nerves such a strain that I feel heartsick, not only of the Bot. Mag. but even of Botany.' Coming from a man who had served botany so long and fruitfully, this was a sorrowful admission indeed. In 1877 he ended his long association with the *Magazine*; he had suggested, however, that his nephew John Nugent Fitch (1840–1927) could lithograph his drawings, for his eyesight was beginning to fail. As Ray Desmond (1987) has said, 'it is sad that the botanical artist who so epitomized the spirit of the Victorian era, its industry, vitality and self-confidence, should have ended his days an embittered man.' Fortunately Joseph Hooker, reflecting, one assumes, on the immense debt he and his father and systematic botany in general owed to

Fitch's devoted service, obtained in 1880 a Civil List pension for him.

Although Fitch by his astonishing output dominated botanical illustration in Britain for so long and established the reputation of Kew as the centre of botanic art, he had no monopoly. Admirable plates by a succession of skilled perceptive artists were published in France during the same period and provide models of accurate and sensitive draughtsmanship. Two of the most impressive works are P. B. Webb and S. Berthelot's *Phytographia Canariensis* (1836–42) and F. Jaubert and E. Spach's *Illustrationes Plantarum Orientalium* (1842–57). Only slightly younger than Fitch, the French botanical artist Alfred Riocreux (1820–1912) made his reputation primarily by drawings for J. Decaisne's *Le Jardin fruitier du Muséum* (1862–75) but contributed numerous plates to other works and to scientific and horticultural periodicals. Whereas Fitch's style may be said to derive from the calico printers, Riocreux's, like that of other French botanical artists, for its fine detail comes more from the miniature painter.

Later artists

FITCH'S BREAK WITH *Curtis's Botanical Magazine* produced a state of emergency for both publisher and editor. Luckily Joseph Hooker's daughter Harriet Anne (1854–1945), now married to William T. Thiselton Dyer, the Assistant Director of Kew, had inherited some of the artistic ability of her father and grandfather. She accordingly provided some plates and several other people also helped to keep the *Magazine* going. Luckily too Hooker had a second cousin Matilda Smith (1854–1926), descended from the sister of Dawson Turner's wife, and he trained her as a botanical artist. From 1886 until 1923 she drew almost all the illustrations for the *Magazine* but John Nugent Fitch, as skilled and industrious as his uncle who had trained him, lithographed and improved her drawings; he himself provided 528 lithographed plates for the *Orchid Album* (1882–97) of Robert Warner, B. S. Williams and Thomas Moore. She was a competent painstaking artist, though not the equal of the two Fitchs, and had the honour of being appointed in 1898 an official Kew artist, the first since Franz Bauer.

In 1891 Otto Kuntze renamed the genus *Naegelia* Regel (1848) non Rabenhorst (1844) as *Smithiantha* for Miss Smith. This name remains in use for a Mexican genus in the Gesneriaceae. The name *Smithiella* given in 1920 by S. T. Dunn to a genus of Urticaceae from the Abor Hills, Assam, and

'respectfully dedicated to Miss Matilda Smith', with the epithet *myriantha* referring to her large number of published illustrations, is antedated by the name *Smithiella* given in 1901 by H. and M. Peragallo to a genus of maritime diatoms. Dunn's genus was renamed *Aboriella* by S. S. R. Bennet in 1981.

Joseph Hooker ended his editorship of the *Magazine* on the completion of vol. 130 (1904). He and his father had been editorially responsible, from vol. 54 (1827) onwards, for the publication of 5,286 hand-coloured illustrations of living plants, many of which had been grown at Kew. Parallel with this had been the issue in *Hooker's Icones Plantarum* from vol. 1 (1836) to vol. 19 (1900), under Hooker editorship, of black and white plates made from herbarium specimens. This tremendous contribution to botanical iconography was mainly the work at Kew of W. H. Fitch and Matilda Smith.

In dealing primarily with the Kew association it would nevertheless be both unjust and misleading not to indicate the quantity of plant illustrations produced elsewhere, notably in France, Austria, Germany and the United States as well as Britain. These range from single works, such as Anton Kerner's self-illustrated classic *Monographia Pulmonariarum* (Innsbruck, 1878; 13 plates) and George Maw's likewise classic self-illustrated *A Monograph of the Genus Crocus* (London, 1880; 77 plates), to others with many volumes, such as C. F. P. von Martius and others' *Flora Brasiliensis* (Munich, 1840–1906), with about 7,560 plates by many artists, and C. S. Sargent's *The Silva of North America* (1890–1902), with 740 plates by Charles Edward Faxon (1846–1918). Faxon was an outstanding American botanical artist who published 1,925 drawings, mostly of trees and shrubs, distinguished by 'accuracy with graceful composition and softness of outline'. The international list of competent artists working at the end of the 19th century and continuing into the 20th is a long one. It correlates with the increasingly large number of plants brought into cultivation or made known by herbarium specimens as a result of European colonization and collecting overseas during the century, together with increasingly cheap methods of graphic reproduction. Botanists consulting the works of Adolf Engler (1844–1930) should be grateful to him for bringing into the service of botany the talent of a young German wood-engraver Joseph Pohl (1864–1939). He worked for Engler over some forty years and produced hundreds of published drawings of new and little-known plants. As stated by Wilfrid Blunt in 1950. 'Pohl belongs to the same class as Matilda Smith and Worthington Smith: his work is conscientious, useful and in great quantity – but not on a high artistic level'.

The twentieth century

BY 1904, when Joseph Hooker, aged 87, relinquished *Curtis's Botanical Magazine* it had long ceased to be a profitable publication, despite its prestige as the world's oldest periodical with hand-coloured plates. The natural history publisher Lovell Reeve (1814–65) rescued the *Magazine* from extinction in 1844 but the firm of Lovell Reeve, which had published it since 1845, reluctantly decided after the end of World War I that they could not afford to lose money by its continuation. They published the last part of vol. 145 in December 1920 and that might easily have been its end but for the efforts of Henry John Elwes (1846–1922). Well known as a traveller, dendrologist and horticulturist, and possessed of an imposing presence and a powerful voice commanding attention, he was able to bring its plight to the notice of others. He decided to save the *Magazine* in which many plants of his introduction and cultivation had been figured. At a dinner of wealthy horticulturists on 21 May 1921 he brought up the question of its revival, especially as the Smithsonian Institution in Washington, DC, had shown a willingness to acquire the copyright. All present wanted the *Magazine* to remain a British publication. Elwes, Lionel Nathan de Rothschild (1882–1942) and Reginald Cory (1871–1934) offered jointly to provide the money required and the copyright was purchased next day. Negotiation with HM Stationery Office and the Ministry of Agriculture failed to make the *Magazine* an official Kew publication. The subscribers then presented the copyright to the Royal Horticultural Society. Fortunately Elwes was able to obtain the services of Lilian Snelling (1879–1972) as artist and Otto Stapf (1857–1933) as editor. Miss Snelling had studied lithography at the Royal College of Art, London and was encouraged to become a botanical artist by Elwes, for whom she drew many plant portraits at Colesbourne, his residence. From 1916 to 1921 she worked as an artist at the Royal Botanic Garden, Edinburgh under the expert supervision of the Regius Keeper, Isaac Bayley Balfour (1853–1922). Although she seems to have published nothing then, Elwes and Balfour appreciated the beauty and accuracy of her superb paintings and the Royal Horticultural Society appointed her to provide the *Magazine*'s illustrations. This she did until her retirement in 1952. Fortunately Elwes and Balfour just outlived the publication in October 1922 of the first part of the revived *Magazine*. This was not vol. 147 part 1, as might have been expected, but vol. 148 part 1.

Volume 147, the '1921' or 'Cory volume', with plates 8874–8933, did not appear until 1938! Cory, a wealthy and generous man fond of books and gardens but no botanist, offered in 1922 to finance a volume for 1921 but even by 1928 he had done little towards its preparation.

Meanwhile Otto Stapf had become editor, another fortunate choice. Born in Austria, he studied at the university of Vienna under Julius Wiesner and then became assistant to Anton Kerner von Marilaun, whose views on the biology of plants were as wide as his specific concept was narrow. Dissatisfied by academic conditions and prospects in Vienna, Stapf accepted in 1890 the post of Assistant in the Kew Herbarium and was Keeper from 1909 to 1922. His retirement thus happily coincided with the vacancy of editor for the *Botanical Magazine*. A good botanical draughtsman himself, he set a higher standard for the *Magazine* both as regards text and illustrations than it had had for many years. His descriptions were based on detailed scholarly research. He worked in an upper room of the Kew Herbarium and so maintained the long-standing Kew association with the *Magazine*. Cory after much procrastination engaged Stapf to work on his proposed volume, which he he did efficiently. At the end of 1932 Cory wanted to alter Stapf's text, already set up in type. This was more than Stapf could stand, as he told me with indignation in January 1933, and he refused to have anything more to do with it. He died in August 1933, Cory in May 1934; the completion of the 1921 volume, for which all the plates had been drawn on zinc and most of the text prepared, now passed into the hands of John Ramsbottom (1885–1974) who finally got it published in 1938.

The major importance of all this from the standpoint of botanical illustration was that it provided opportunity for Lilian Snelling to prove herself one of Britain's greatest botanical artists. She established her reputation not only by numerous illustrations in the *Magazine* but also by others in F. C. Stern's *A Study of the Genus Paeonia* (1946) and A. Grove and A. D. Cotton's *A Supplement to Elwes' Monograph of the Genus Lilium* (1934–40). When dedicating to her vol. 169 (1952–3) the Royal Horticultural Society paid tribute to the 'remarkable delicacy and accuracy of outlines, brilliancy of colour and intricate gradation of tone'. She had faithfully portrayed most of the plants figured in the *Magazine* from 1922 to 1952.

The *Botanical Magazine* barely survived World War II. Hitherto the plates had been hand-coloured. By 1947 the lack of colourists for so tedious a task compelled the Royal Horticultural Society to adopt from 1948 onwards various processes of mechanical colour reproduction. Lilian Snelling retired

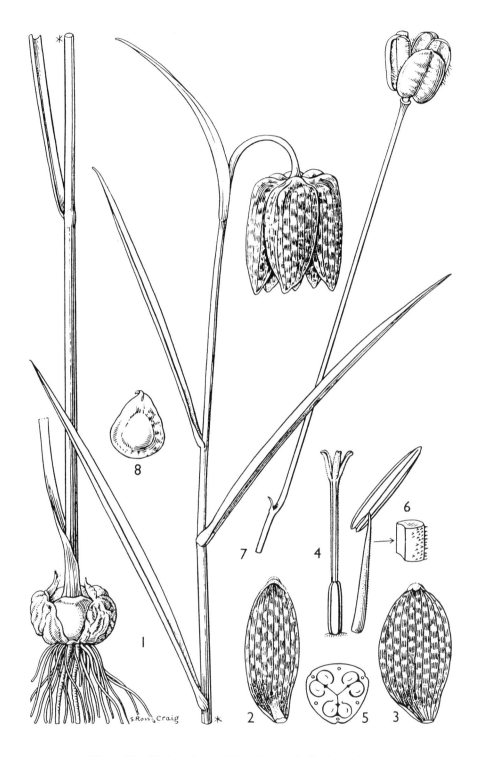

Fig. 4 *Fritillaria meleagris* (Drawing by Stella Ross-Craig;
from *Hooker's Icones Plantarum* t. 3839; 1980)

35

in 1952 and three much younger artists of high ability and standards took over the preparation of the *Magazine*'s illustrations: Stella Ross-Craig, Ann Webster and Margaret Stones. All have made notable published contributions to the portrayal of plants apart from the *Magazine*. Thus Margaret Stones illustrated among other works Winifred Curtis's *The Endemic Flora of Tasmania* (1967–78) depicting gracefully and accurately 253 of its unique plants. Ann Webster's illustrations have appeared in G. H. Johnstone's *Asiatic Magnolias in Cultivation* (1965) and volumes of the Kew series (*British Trees and Shrubs*, 1958; *Garden Trees and Shrubs*, 1960; *British Ferns and Mosses*, 1960) demonstrating her versatility and skill. The impressive record of Stella Ross-Craig (b. 1906), whose association with Kew began in 1929, brings to mind that of Walter Hood Fitch. The task of an artist working for a botanical garden or museum is to make illustrations not only for publication but also as archival records for later research. Miss Ross-Craig's drawings and paintings in the Kew collection amount to around 3,000; these include 460 black-and-white illustrations for *Hooker's Icones Plantarum* and seventy-five for the *Flora of West Tropical Africa*. Her most remarkable achievement is her *Drawings of British Plants* (published in 31 parts, 1948–73), with 1,286 full-page black-and-white illustrations of uniform high quality. They portray with unimpeachable accuracy not only the habit and floral details of flowering plants growing naturally in the British Isles but also their fruits and seeds, the latter at magnifications of 6 to 20, a most valuable feature as information about these is often hard to find. For completion of this immense self-imposed task, done independently of her official Kew work, she has earned the lasting gratitude of botanists concerned with the European flora.

Very appropriately the Royal Horticultural Society dedicated vol. 182 (1978–80) to Stella Ross-Craig and her husband Joseph Robert Sealy who had begun their association with the *Magazine* more than fifty years earlier under the editorship of Otto Stapf and had diligently upheld its high standards, combining integrity in science and excellence in art. Later artists contributing to the *Magazine* before its decease were Mary Grierson, Christabel King, Pandora Sellars and Ann Farrer, all dealt with elsewhere in the present volume.

Curtis's Botanical Magazine, which began publication in February 1787 and became a profitable undertaking for its founder William Curtis (1746–99), ceased publication in October 1983 having reached its 184th volume and 10,570th plate (N.S. 882). Between 1835 and 1837 William Hooker published *A Companion to the Botanical Magazine ... containing such interesting*

Fig. 5 *Utricularia recta* (Drawing by Peter Taylor)

botanical information as does not come within the prescribed limits of the Magazine. This was an independent journal with miscellaneous articles. Later, between 1845 and 1848, he published within volumes 71–78 of the *Magazine* itself a *Companion to the Botanical Magazine (New Series) of similar character. This gave precedent for the creation of a new periodical The Kew Magazine, incorporating Curtis's Botanical Magazine,* of which the first part was published in April 1984. Coloured plates with descriptions, usually six in a part, continue to be the essential feature, as in the original *Magazine,* but articles on plant-collecting, travel, endangered species, small genera, book reviews etc. widen its interest and supplement them with line-drawings and maps in the text. It is thus a modern equivalent of *Curtis's Botanical Magazine* as it was in the years 1845 to 1848.

Although most of the plates contributed to *The Kew Magazine* have been the work of Pandora Sellars and Christabel King, with a few by Ann Farrer, Mary Grierson and Margaret Stones, it has provided the opportunity for botanists and gardeners to admire the excellent illustrations by other artists associated with Kew or Edinburgh, notably Mark Fothergill, Victoria Goaman, Joanna Langhorne, Valerie Price and Rodella Purves, maintaining the high standards of their predecessors. Most of the plants of Europe have been illustrated, often and well, particularly those of the British Isles, but there remains a vast quantity of plants elsewhere, notably in the tropics, that nobody has ever portrayed. Good photographs can adequately express a plant's habit of growth but can never reveal the significant detail selected by a discerning and experienced artist. For this the modern Kew artists, varied though are their individual styles, share a great tradition of service to botany and are proving worthy exponents of the best botanical iconography. To this tradition belong several Kew botanists not professional artists who have illustrated their own publications, of which the most prolific has been John Hutchinson (1884–1972), the author among much else of *A Botanist in Southern Africa* (1946), *British Wild Flowers* (1972), *The Families of Flowering Plants* (3rd edn 1973), *Evolution and Phylogeny of Flowering Plants* (1969), all with informative line drawings. The greatest single iconographic achievement by a modern Kew botanist is *The Genus Utricularia* (1989) by Peter Geoffrey Taylor (b. 1926), his 214 illustrations there portraying in elaborate meticulous detail the minute characters of all the accepted species.

For sources of further information, see pages 158–9.

THE PLATES

PLATE I

Gentiana depressa D. Don Gentianaceae

ARTIST: MARY BATES

There are about fifty species of *Gentiana* in Nepal whereas the whole of Europe has not more than thirty. *Gentiana depressa* was among the first of the numerous Sino-Himalayan species to be named and described, having been published by David Don in 1825, but it was not introduced into cultivation until 1924. The flowers are large indeed for the little rosettes of leaves, only 1–2 cm ($\frac{2}{5}$–$\frac{4}{5}$ in.) across, on which they sit. The species ranges from Central Nepal to Bhutan and south Tibet, growing on open slopes at 2,900–4,300 m (9,500–14,100 feet).

Painted in October 1988 as a private commission.

PLATE 2

Aeschynanthus chrysanthus P. Woods

Gesneriaceae

ARTIST: MARY BATES

The genus *Aeschynanthus* comprises about 100 species in India, the Malayan region and Indonesia, most of them epiphytic on trees. Of these about fifteen have been in cultivation. They are mostly trailing plants with rather leathery or fleshy leaves and conspicuously long-tubed flowers ranging in colour from red and orange to yellow and greenish. The present species introduced from Sumatra has both the calyx and corolla lemon-yellow with brown lines on the corolla-lobes. In gardens it has become known under the provisional name 'Sunburst'.

Painted in October 1987 for future publication in The Kew Magazine.

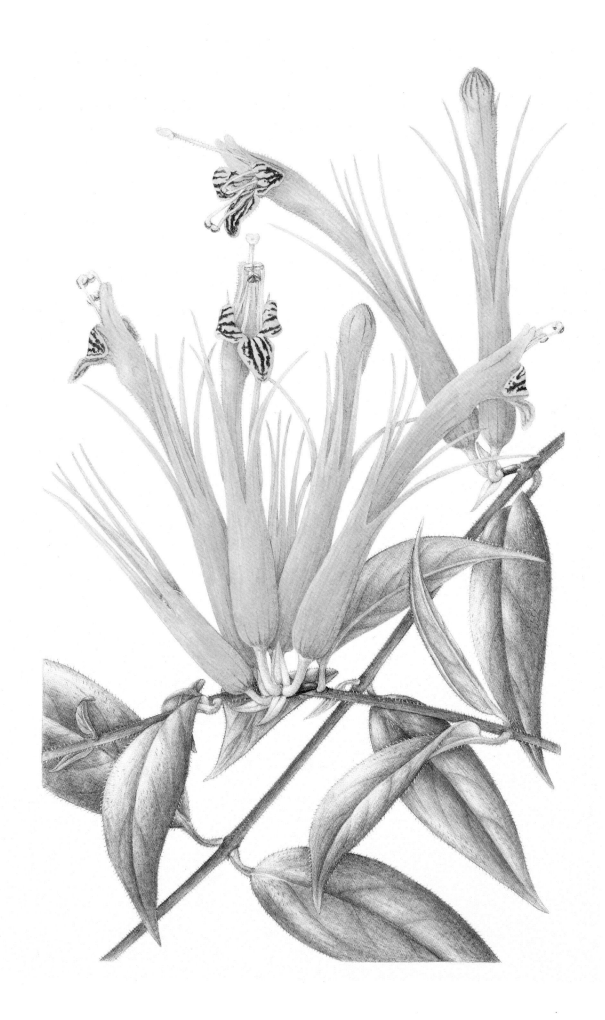

PLATE 3

| *Primula elatior* (Linnaeus) Hill | Primulaceae |
| *Anemone nemorosa* Linnaeus | Ranunculaceae |

ARTIST: MARJORIE BLAMEY

The three readily distinguishable British species of *Primula* known as the Primrose (*P. vulgaris* Hudson), the Cowslip (*P. veris* Linnaeus) and the Oxlip (*P. elatior*) were included by Linnaeus in one species which he called *Primula veris*, actually an old two-word generic name meaning the 'firstling of spring', but he distinguished them as varieties *acaulis, officinalis,* and *elatior*. The oxlip has a wide distribution on the continent of Europe but a restricted one in Britain's East Anglian region. It resembles the cowslip in having its flowers on an evident stem but these are larger and flatter; it prefers deciduous woodland, whereas the cowslip grows in more open situations, in meadows and pastures.

The Wood Anemone, *Anemone nemorosa*, on the other hand, occurs throughout Britain though with a similar preference for deciduous woodland. The flowers are white or pink-tinged; there exist, however, many garden forms, some with double flowers, some with delicate pale blue flowers.

Painted in 1989 from a specimen found in coppiced woodland in Suffolk.

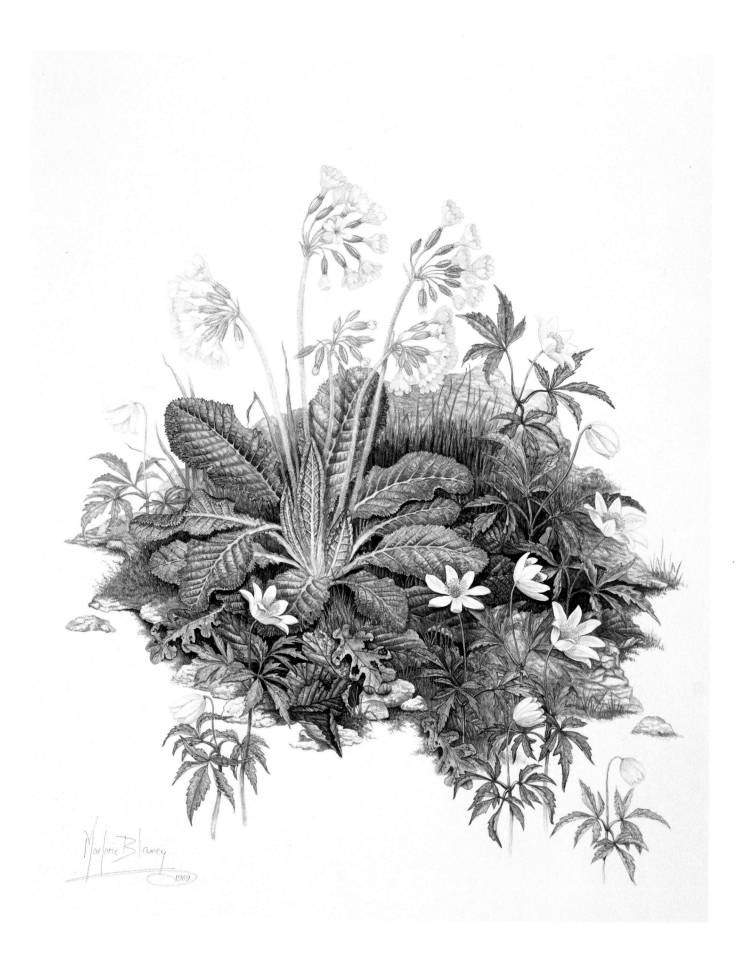

PLATE 4

Fritillaria meleagris Linnaeus Liliaceae

ARTIST: MARJORIE BLAMEY

The Snakes-Head Fritillary, *Fritillaria meleagris*, grows wild here and there in damp meadows in England, being usually abundant where it occurs, and is protected from flower pickers. It has acquired a number of local names, such as Chequered Lily, Dead Man's Bells, Weeping Widow etc., but there can be no doubt that in some places at least, if not all, it has escaped from cultivation or been deliberately naturalized. For example, near Uppsala, Sweden, where this fritillary occurs abundantly in a damp habitat, producing many white forms, and has all the appearance of being native, it is known to have been introduced by Olof Rudbeck the Elder (1630–1702).

No British botanist before 1737 recorded '*Fritillaria meleagris* as a wild plant; then John Blackstone stated it grew in a meadow near Ruislip Common not far from Harefield, Middlesex, 'observed above 40 years by Mr Ashby' i.e. before 1696. John Parkinson in 1629 called it '*Fritillaria vulgaris*. The common checkered Daffodill' with hanging flowers 'of a reddish purple colour, spotted diversely with great spots, appearing like unto square checkers'; it was 'first brought to our knowledge from France, where it grows plentifully about Orleance [Orleans]'. Clusius in 1583 recorded that the name *Fritillaria* was coined by Noel Caperon, a druggist at Orleans, from *fritillus*, 'a dice box' but referring to 'the table or boord upon which men play at Chesse, which square checkers the floure doth very much resemble' or 'the Tables whereat men play at Dice'. Another 16th-century name was *Flos Meleagris* or *Flos Meleagridis*, rendered in English as 'Ginny-hen Floure'. *Mĕlĕagris* was the Ancient Greek and Latin name for guineafowl (*Numidia meleagris*). The species has a wide distribution in Europe north of the Mediterranean region.

Painted from a group of plants in the artist's garden in Cornwall.

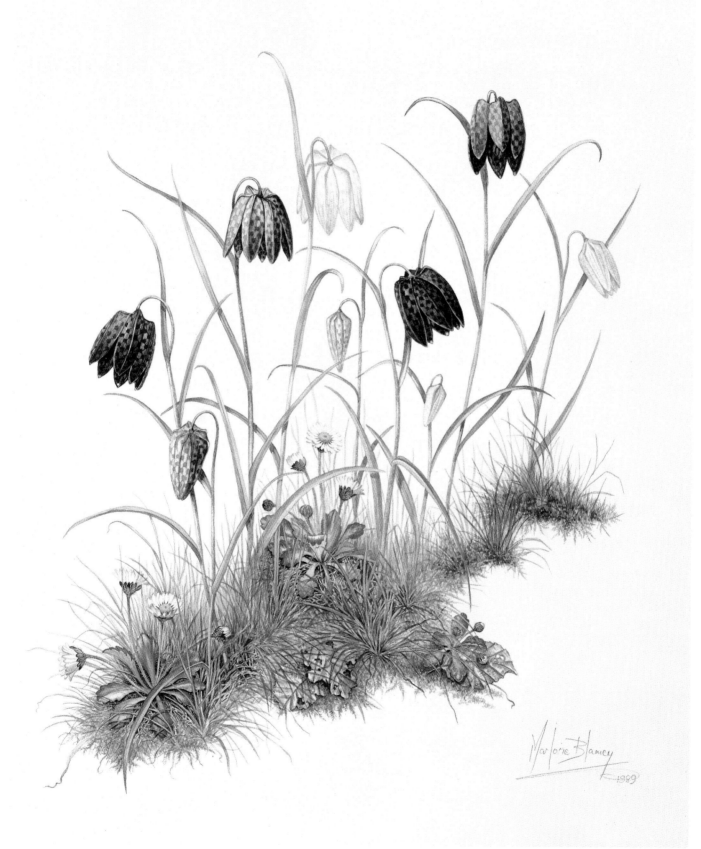

Marjorie Blamey 1989

PLATE 5

Cypripedium calceolus Linnaeus Orchidaceae

ARTIST: MARJORIE BLAMEY

The beauty and remarkable flower-form of the European Lady's Slipper Orchid have been its undoing in Britain and elsewhere by tempting gardeners to uproot clumps and thereby extirpate it in the wild. The 16th-century herbalists Conrad Gessner (Gesnerus) and Charles de l'Ecluse (Clusius) recorded its German vernacular names as 'Marienschuth' and 'Unser frawen schuth', meaning 'the shoe of Our Lady the Virgin Mary', rendered into Latin as *Calceolus Mariae* and later into English as 'Our Ladies Slipper'. John Gerard in 1597 knew it solely as a foreign plant, but John Parkinson in 1629 recorded 'this most beautiful plant of all these kindes' not only from the European continent but from northern England, stating that 'it groweth likewise in Lancashire ... not farre from Ingleton, as I am enformed by a courteous Gentlewoman, a great lover of these delights, called Mistris Thomasin Tunstall ... who hath often sent mee up the rootes to London, which hath borne faire flowers in my Garden.' Courteous Thomasin Tunstall has had far too many successors. Unwittingly she began its tragic decline as a British plant. Others made a profit by its eradication. Thus late in the 18th century, at Settle in North Yorkshire, plants from the wild were being sold in the market place. Now only one wild-growing native plant exists in Britain.

This slipper orchid has a wide distribution in Europe and in northern Asia but through human depredation it has disappeared from many localities and hence has had to be protected by legislation.

Sketched from a group of these rare plants found in a small woodland on the French/Spanish border.

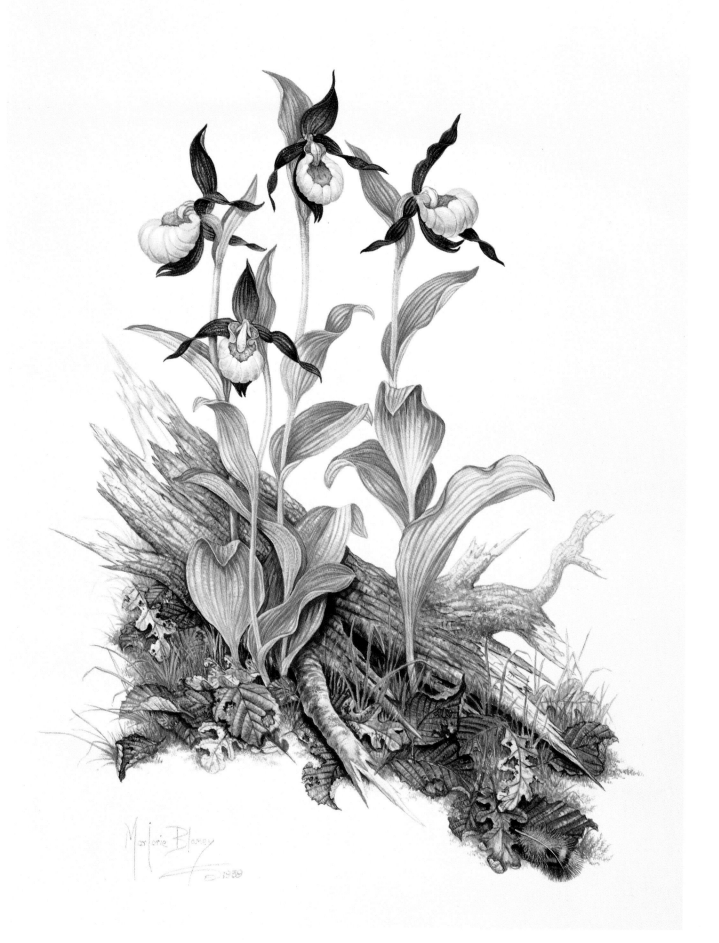

Marjorie Blamey 1989

PLATE 6

Some British Composites Compositae (Asteraceae)

ARTIST: JILL COOMBS

The enormous botanical family of worldwide distribution called the Compositae, estimated to comprise 20,000 or more species placed in about 1300 genera, is represented in the British Isles by about sixty native or introduced genera. Of these, six are portrayed here. Members of the family vary in habit from tropical trees and climbers to minute annuals, but all possess small flowers (florets) crowded together in heads which give the effect of being single flowers. All the florets may be alike, or have the outer ones (ray florets, ligulate florets) much larger than and differently coloured from the central ones (disc florets) which they surround.

TOP LEFT *Matricaria perforata* Mérat syn. *Tripleurospermum inodorum* (Linnaeus) Schultz Bip., Scentless Mayweed. A common annual weed of cultivated land and roadsides over most of the British Isles.

TOP CENTRE *Bellis perennis* Linnaeus, Daisy. A familiar weed of lawns, which occurs throughout the British Isles in closely grazed grassland, this was a favourite flower of Chaucer who wrote 'of alle the floures in the mede, Than love I most these floures white and rede, Swiche as men callen daysies in our toun.'

TOP RIGHT *Cichorium intybus* Linnaeus, Chicory. Notable both for its large blue flower-heads and its roots which, when dried and ground, provide the chicory used as a coffee substitute.

CENTRE *Tussilago farfara* Linnaeus, Coltsfoot. Flowers in spring before the large heart-shaped leaves arise and occurs throughout the British Isles.

BOTTOM LEFT *Taraxacum officinale* Weber, Dandelion. This is not a sexually reproducing species but a large group of variants which reproduce true to their individual characteristics by seed produced without fertilization. Hundreds of such variants (apomictic species) have been described from Scandinavia and the British Isles.

BOTTOM RIGHT *Petasites fragrans* (Villars) C. Presl, Winter Heliotrope. A native of North Africa, introduced into European gardens in the 18th century for its vanilla-scented flowers and now naturalized in many places.

Painted in 1981 as an experimental plate for The Herbert Press.

50

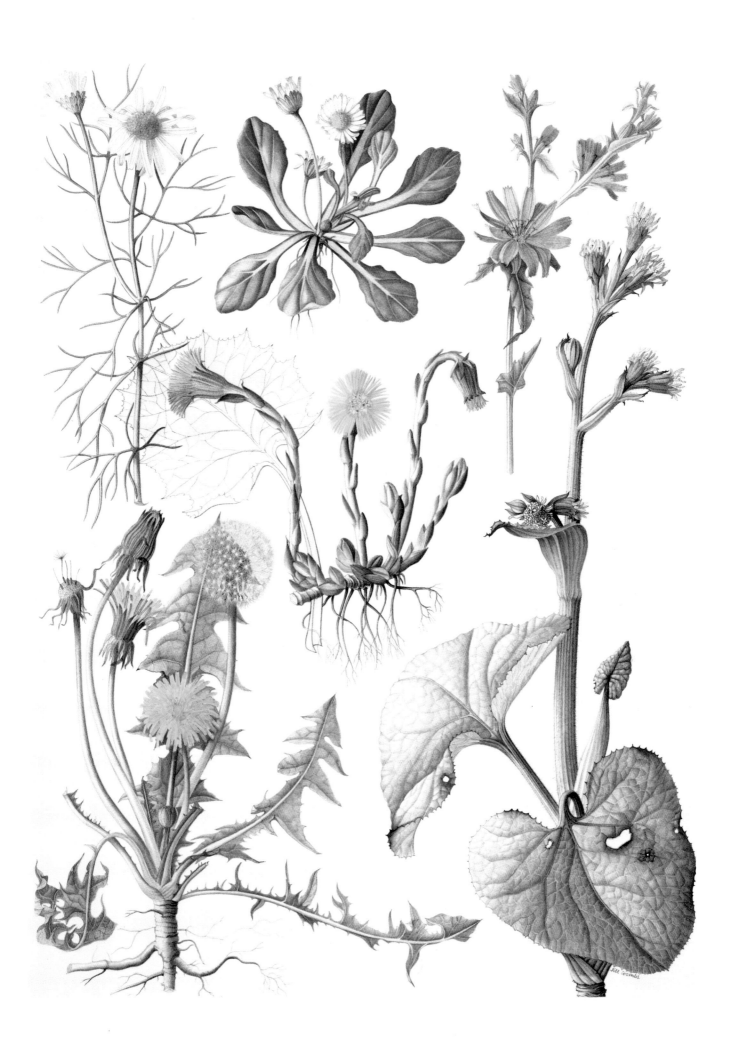

PLATE 7

Zea mays Linnaeus Gramineae (Poaceae)

ARTIST: JILL COOMBS

Maize, Indian Corn or, as it is usually called in the United States, Corn, is with the Irish potato and the sweet potato one of the most important food plants that the world owes to the ancient primitive cultivators of America. It differs fundamentally from other grasses in having the female inflorescences (which produce the heavy 'corn cobs') almost stalkless in the axils of leaves low on the stem while the branched male inflorescence terminates the stem. The female inflorescence is enclosed within short leaves called 'husks', out of which at the tip protrude a bunch of styles called the 'silks'. The male inflorescence, called the 'tassel', produces millions of pollen grains, which are carried on the air to the styles (silks) below. The seeds, being so firmly attached to the central stalk of the corn cob and so encased by the husks, lack any means of dispersal; in a wild plant this would be a lethal situation but to humans it is highly advantageous. There exists no corresponding wild plant. The origin of maize is controversial, with two distinguished American botanists P. C. Mangelsdorf and Hugh Iltis putting forward opposed views. Remains going back some 5,600 years found in caves in Mexico indicate its antiquity.

Maize was evidently introduced into Spain by Christopher Columbus but by 1542, when Fuchs published the first illustration of the whole plant, its American origin had been so forgotten that he called it '*Turcicum frumentum. Türkisch korn*'.

Exhibited at the Royal Horticultural Society in 1978 and now in private ownership.

PLATE 8

Malus × *robusta* (Carrière) Rehder Rosaceae

ARTIST: JILL COOMBS

Names of animals forming part of plant names often have no direct relevance to the animal itself but imply inferiority to some other plant, e.g. Dog Rose, Dog Violet, Horse Mushroom, Toadflax. Whether the designation 'Crab Apple' for wild apples inferior in taste to the cultivated orchard apples so originated, is uncertain; it may be a variant of the Scandinavian 'skrabba', Scottish 'skrab'. In any event the crab apples, notably *Malus baccata* (Linnaeus) Borkhausen, the Siberian Crab, and hybrids derived from it, provide gardens with trees ornamented in flower or fruit or both. To these belongs a hybrid group derived from *M. baccata* and *M. prunifolia* (Willdenow) Borkhausen, with small but conspicuous abundantly produced fruits which hang for a long time on the tree. *Malus* × *robusta* is such a hybrid.

Gardeners have always distinguished apples (*Malus*), pears (*Pyrus*) and quinces (*Cydonia*), but Linnaeus in 1753 put them all in the same genus under the name *Pyrus*. His contemporary Philip Miller of the Chelsea Physic Garden, who was both a practical gardener of great experience and a botanist, disagreed. In 1768 he stated 'the Apple should be separated from the Pear, this distinction being founded in nature; for these fruits will not take by budding or grafting upon each other, though it be performed with the utmost care, therefore I shall beg leave to continue the separation of the Apple from the Pear, as hath always been practised by the botanists before his time.' There are also small floral differences. Modern botanists accept Miller's separation of *Malus*, *Pyrus* and *Cydonia*. Accordingly the species formerly known as *Pyrus baccata*, *P. coronaria*, *P. hupehensis*, *P. kansuensis* and *P. niedzwetzykana*, notable for its deep red flowers and fruits, are now placed in the genus *Malus*.

Painted in 1989 for an exhibition at the Broughton Gallery, Scotland, and subsequently at the Kew Gardens Gallery.

54

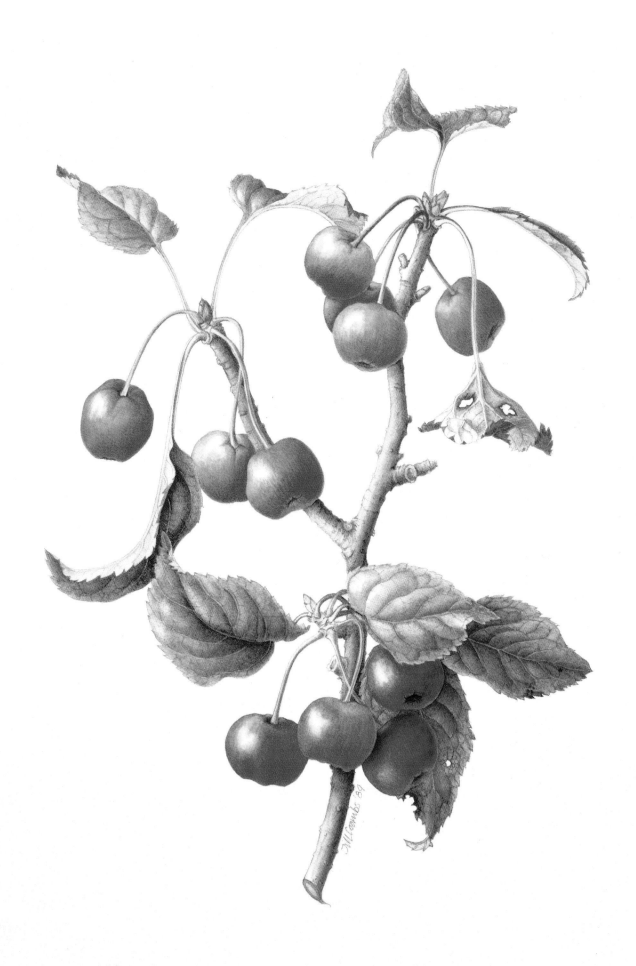

PLATE 9

Dionaea muscipula Ellis Droseraceae

ARTIST: BARBARA EVERARD

From 1759 onwards the eastern North American insectivorous plant, which a London merchant and naturalist John Ellis (*c.* 1705–76) in 1770 named *Dionaea muscipula* or Venus's fly-trap, has excited the interest of botanists and gardeners. It forms a rosette of outspread extraordinary leaves; the lower part, a very broad green leaf-stalk, supports two distinct hinged lobes 1.5–3 cm ($\frac{1}{2}$–$1\frac{1}{4}$ in.) long, reddish with minute glands and three erect bristles on the upper side, green below, and fringed with long bristles. Their colour and sugar lure insects. When an insect alights on the attractive lobes, they rapidly close together like a spring mouse-trap, holding and squashing the unlucky insect, which thereafter provides the plant with nutrient. Naturally so remarkable a plant, the only one of its genus, greatly interested Charles Darwin, who in his book *Insectivorous Plants* (1875, 2nd edn 1888) devoted a whole chapter to it. 'This plant', he said, 'commonly called Venus' fly-trap, from the rapidity and force of its movements is one of the most wonderful in the world.' The plant bears a cluster of wide-open flowers about 1.5 cm ($\frac{3}{4}$ in.) across with five white petals and ten stamens.

The name *Dionaea* is an alternative Greek designation of the goddess Aphrodite (Venus); Latin *muscipula* means 'mouse-trap'. The caught insect causes the glands to secrete an acid fluid.

From the collection held at the Royal Botanic Gardens, Kew, for the Barbara Everard Trust for Orchid Conservation.

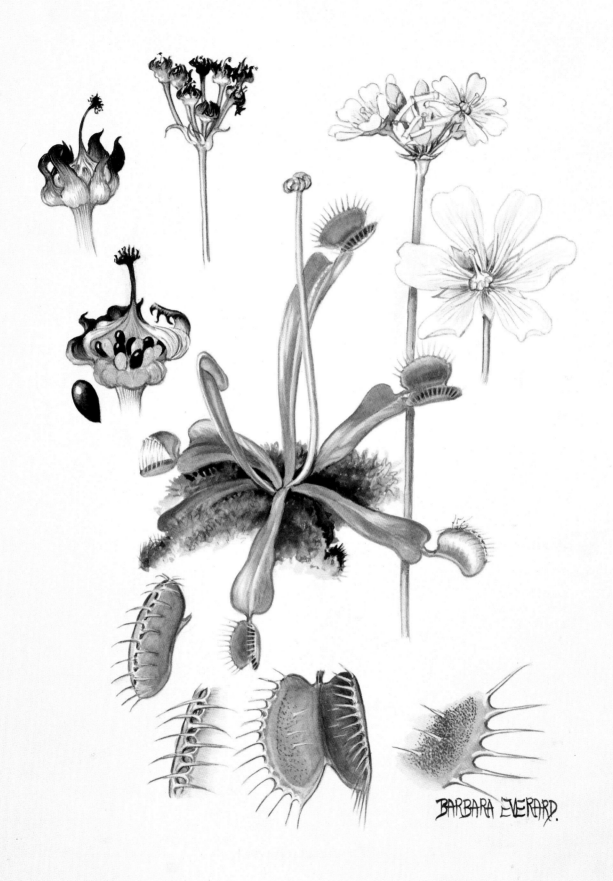

Dionaea musipula

BARBARA EVERARD.

PLATE 10

Didymocarpus crinitus Jack Gesneriaceae

ARTIST: BARBARA EVERARD

Didymocarpus is predominantly an Indo-Malayan genus, with a few outlying species in Madagascar and tropical Australia. Of the 150 or so species, many of them attractive, only six are in cultivation, the first introduced being *D. crinitus* from Malaya. This was discovered and described by William Jack (1795–1822), a Scottish medical man who accompanied Stamford Raffles to Sumatra, where he died. It has a short stem with the sharply toothed leaves, ruddy beneath, crowded into a rosette, out of which arise the long-tubed white or lavender flowers on single stalks. All species of *Didymocarpus* need the protection of a warm glasshouse in Britain.

From the collection held at the Royal Botanic Gardens, Kew, for the Barbara Everard Trust for Orchid Conservation.

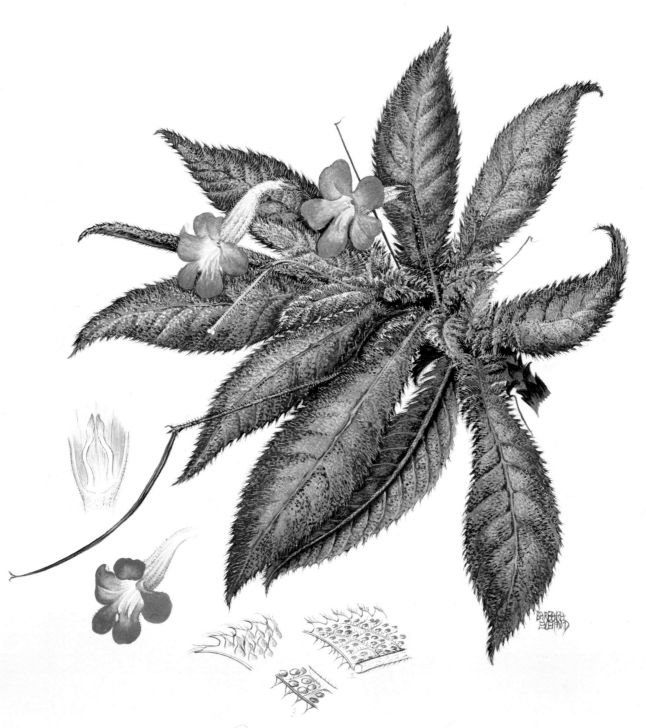

Didymocarpus crinita.

PLATE 11

Franklinia alatamaha Bartram ex Marshall Theaceae

ARTIST: BARBARA EVERARD

Long extinct in its only known habitat, a small area in Georgia, USA, Franklin's Tree, *Franklinia alatamaha*, has been maintained in cultivation since 1778 and, on account of both its beauty and interest, especially merits conservation in gardens. It is the only species of its genus, the generic name commemorating Benjamin Franklin (1706–90), the many-sided American printer, journalist, inventor, scientist and statesman, who among much else invented the rocking chair and the lightning conductor. On an exploring journey in 1765 the Philadelphia farmer and botanist John Bartram (1699–1777) with his artistic son William (1739–1823) stayed for a few days in September 1765 at Fort Barrington on the Altamaha (Alatamaha) River, Georgia. Here they found some trees of a then unknown genus for which Bartram proposed the name *Franklinia* in honour of his friend Benjamin Franklin, although the name itself was not published until 1785. The whole population occurred on only two or three acres. This was on John Bartram's last major journey, but William collected seed of the *Franklinia* there in 1773; Moses Marshall (1758–1813) saw it there in 1790, John Lyon (*c.* 1765–1814) in 1803. Nobody has later recorded it in the wild.

This species may grow into a tree to 10 m (30 feet) high, with deciduous leaves, which turn crimson in autumn, and fragrant white flowers about 7–10 cm (3–4 in.) across in late summer or early autumn.

From the collection held at the Royal Botanic Gardens, Kew, for the Barbara Everard Trust for Orchid Conservation.

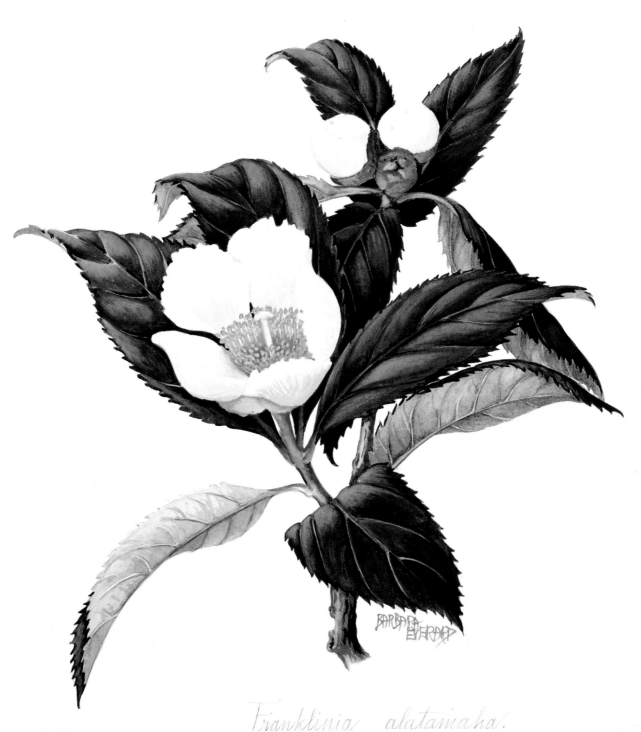

Franklinia alatamaha.

PLATE 12

Cotoneaster microphyllus Lindley Rosaceae

ARTIST: ANN FARRER

As the specific epithet indicates, *Cotoneaster microphyllus* has some of the smallest leaves in the genus *Cotoneaster*; they are about 5–8 mm ($\frac{1}{4}$–$\frac{1}{2}$ in). long, thus roughly the same size as those of allied species, *C. conspicuus* Marquand, *C. adpressus* Bois, *C. congestus* Baker and *C. horizontalis* Decaisne. These are mostly low-growing densely branched shrubs of spreading and almost prostrate habit, thus suitable in gardens for ground-cover, and come from eastern Asia. The flowers are small, about 8–9 mm. ($\frac{1}{4}$–$\frac{1}{2}$ in.) across, with spreading white or pinkish petals. The attractiveness of *C. microphyllus*, and these allied species, lies in their profuse small red fruits; its leaves often become reddish in late autumn. It is a Himalayan species extending from Nepal to western China and was introduced into British gardens in 1824. Birds like the fruits of cotoneasters, although these may last on the plants for most of the winter. Evidently spread by birds, *C. microphyllus* has become naturalized on rocks and cliffs here and there in England and Ireland.

The name *Cŏtōnĕaster* is a compound of Latin *cŏtōnĕa*, 'quince', and the suffix *-aster* indicating inferiority as in *ŏlĕaster*, 'wild olive'; it is of masculine not feminine gender.

Painted in 1986 from material grown at Wakehurst Place, Sussex.

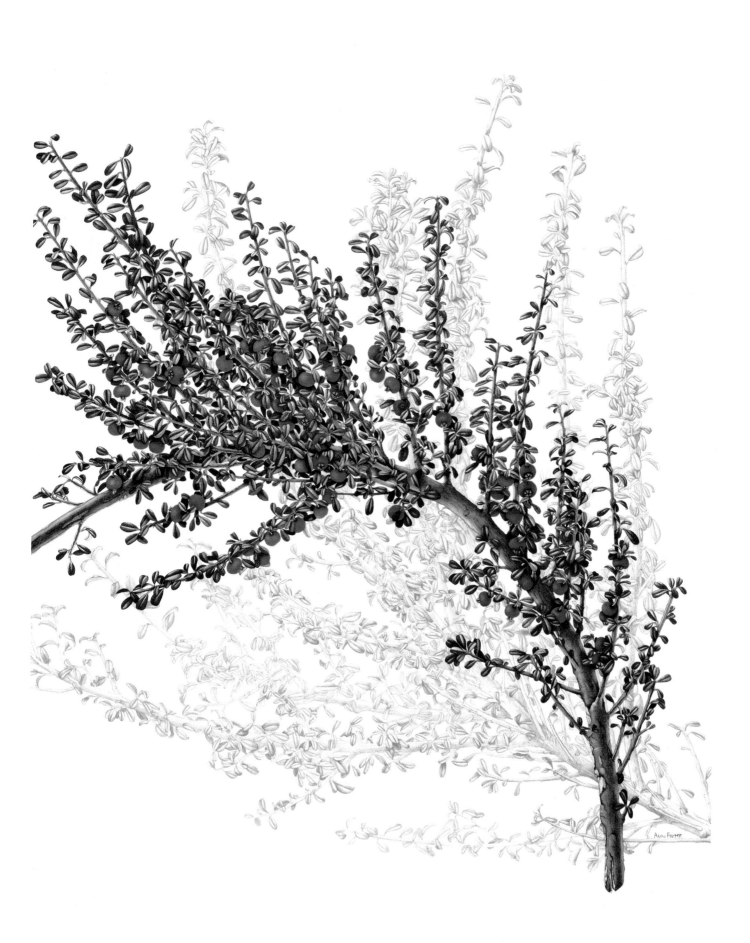

Ann Forret

PLATE 13

Pinus wallichiana A. B. Jackson Pinaceae

ARTIST: ANN FARRER

Two species of pine grow in the Western Himalaya, *Pinus roxburghii* Sargent, with leaves in clusters of three, and *P. wallichiana*, with leaves in clusters of five, unlike the Scots Pine, *P. sylvestris* Linnaeus, which has leaves in pairs. They commemorate two pioneers of Indian botany, William Roxburgh (1751–1815), a Scot who was Superintendent of the Calcutta Botanic Garden from 1793 to 1813, and Nathaniel Wallich (1786–1854), a Dane who was Superintendent from 1815 to 1841. Both were medical men in the service of the Hon. East India Company.

Wallich's Pine extends from Afghanistan over Kashmir to eastern Nepal and Bhutan. It makes a tree up to 50 m. (150 feet) high with long pendulous leaves to 20 cm (8 in.) long. This species was named by Wallich *Pinus excelsa* in 1824 but that name had already been used for another species by Lamarck in 1778. A. B. Jackson accordingly renamed it *P. wallichiana* in 1938. It was first introduced into cultivation in 1823.

Painted in 1986 from material grown at Wakehurst Place, Sussex.

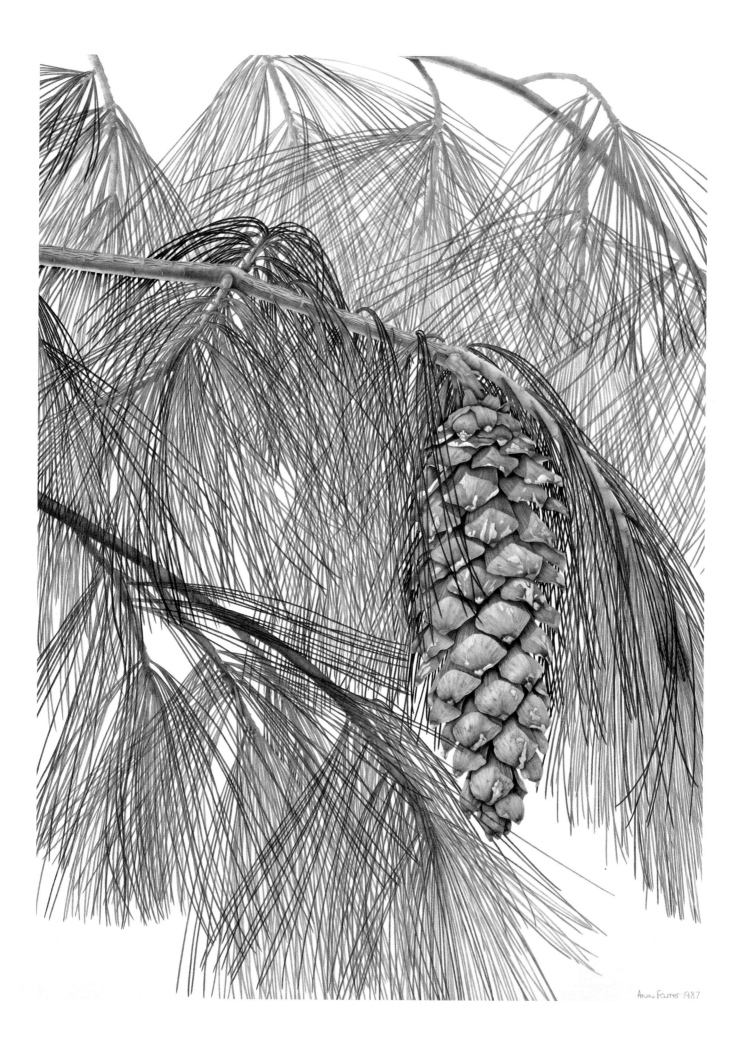

Ann Foster 1987

PLATE 14

Pieris japonica (Thunberg) D. Don Ericaceae

ARTIST: ANN FARRER

Carl Linnaeus (1707–78), the founder of modern botanical nomenclature, gave the name *Andromeda* to a little Lapland plant belonging to the family Ericaceae because it brought to his vivid imagination the story in Greek mythology of Andromeda who was rescued from a sea-monster by Perseus. David Don (1800–41), when naming new genera of Ericaceae in 1834, followed Linnaeus's example and took from Greek mythology the names *Cassiope* (*Kassiŏpe*, mother of Andromeda), *Cassandra* (the disbelieved prophetess), *Leucōthoē* (a mythical princess loved by Apollo), and *Pĭeris* (one of the female singers called the Pierides, being daughters of Pieros). To *Pieris* Don transferred a Japanese species named *Andromeda japonica* Thunberg in 1784. First collected near Nagasaki, this species is now known to occur widely in Japan, being recorded from Honshu, Shikoku and Kyusu.

Pieris japonica is very close to the variable *P. formosa* (Wallich) D. Don, of which the clone 'Wakehurst' with brilliant red young leaves is the best-known variant in gardens; the latter species, first described from Nepal as *Andromeda formosa*, ranges from there to central China. Both are evergreen shrubs rising to 3 m ($9\frac{1}{2}$ feet) or more with profuse white pitcher-shaped flowers. *P. japonica* has inflorescences more pendulous than those of *P. formosa*; the flowers are about 8 mm ($\frac{5}{16}$ in.) long.

Painted in 1988 as a private commission, from material grown at Wakehurst Place, Sussex.

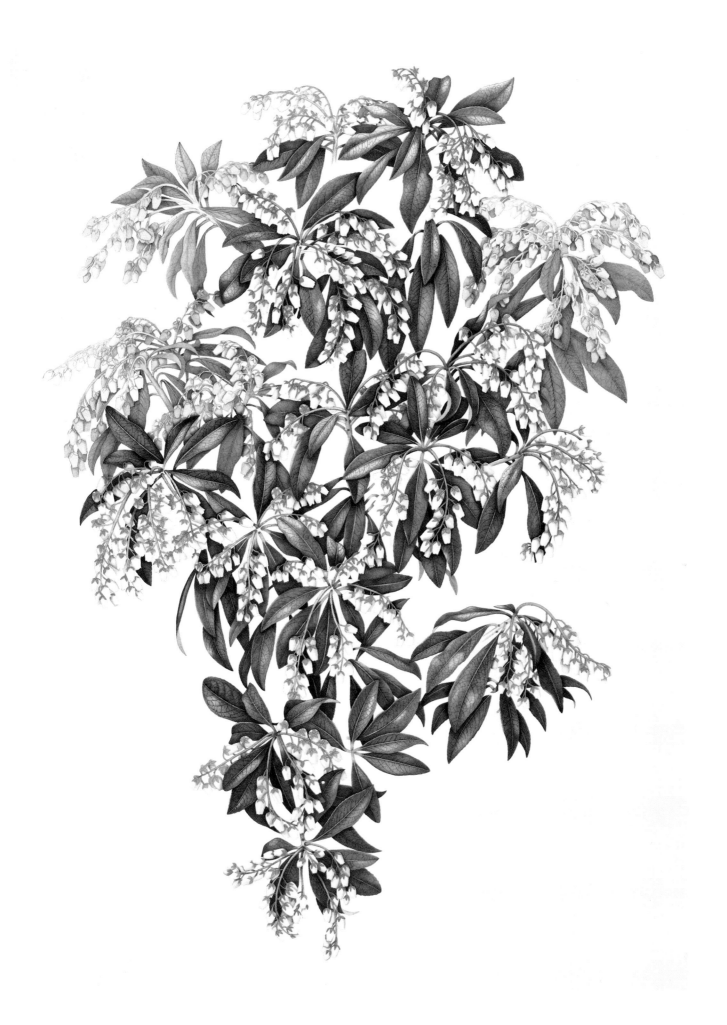

PLATE 15

Clianthus formosus
(G. Don) Ford & Vickery Leguminosae (Fabaceae)

ARTIST: MARK FOTHERGILL

Sturt's Pea, also known as Sturt's Desert Pea, is the Australian representative of the genus *Clianthus*, which has another species, the Parrot's Beak or Red Kowhai, *C. puniceus*, in New Zealand and six others in Malaya, the Philippines and Indo-China, all with large conspicuous flowers. William Dampier (1652–1715), pirate, marine explorer and hydrographer, collected a specimen on the western coast of New Holland (now Western Australia) in 1688 and illustrated it in his *New Voyage round the World* (1697) as *Colutea Novae Hollandiae*, a sound guess at its affinity for *Clianthus* and *Colutea* are closely allied genera; later it was named *Clianthus dampieri*. This species is now known to grow over a wide area in semi-desert tropical Australia. Of spreading prostrate growth, it is one of Australia's most spectacular wild flowers when in full bloom. The flowers are about 9 cm ($3\frac{1}{2}$ in.) long, the erect upper petal (standard) being scarlet with a large black-purple swelling at the base, the two side petals (wings) and the lower two joined petals (keel) plain scarlet and pointing downwards. The name 'Sturt's Pea' commemorates Captain Charles Sturt (1795–1865), one of the most intrepid of Australia's many heroic explorers, who led several risk-taking expeditions into the continent's interior.

Painted in 1989 from a specimen grown from seed in the Australian House at the Royal Botanic Gardens, Kew. The floral emblem of South Australia.

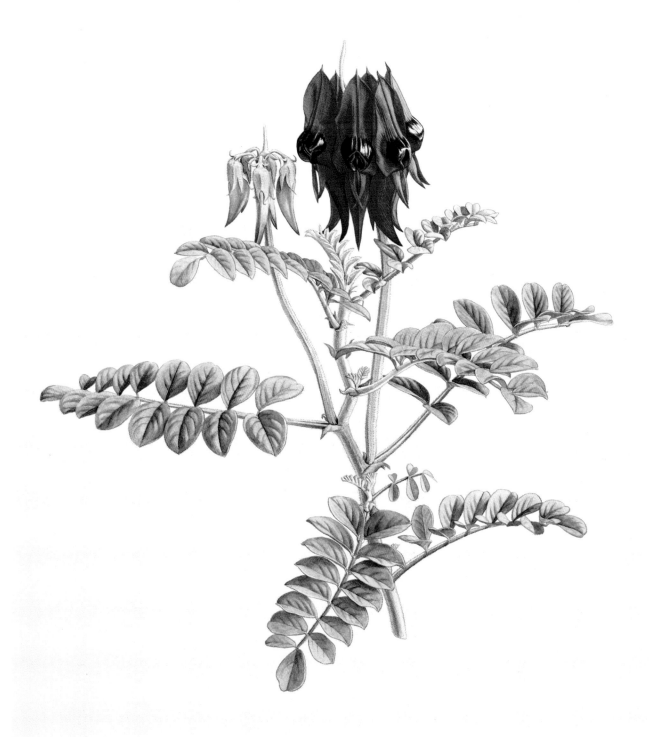

Clianthus formosus John Maple Fothergill 28-7-89

PLATE 16

Hippeastrum chilense (L'Héritier) Baker Amaryllidaceae

ARTIST: MARK FOTHERGILL

Whereas the species commonly associated with the name *Hippeastrum*, notably *H. puniceum* (Lamarck) Voss (syn. *H. equestre* (Aiton) Herbert) and its cultivars, have broad leaves, to 5 cm (2 in.) wide, and large flowers up to 12 cm (5 in.) long, there are a few species in Chile with very narrow leaves, to 1.5 cm ($\frac{1}{2}$ in.) wide and smaller flowers, up to 6.5 cm ($2\frac{1}{2}$ in.) long. These have been separated from *Hippeastrum* proper and placed in a genus *Rhodophiala* C. Presl (from *rhodos*, red, *phialé*, a shallow bowl) which has gained little acceptance. *Hippeastrum chilense*, originally named *Amaryllis chilensis* by L'Héritier, is one of these. It has narrow leaves developing at the same time as the flower-stem, to 30 cm (1 ft) high, which bears one to three funnel-shaped flowers up to 5 cm (2 in.) long. The plant illustrated was collected in the Concepción district of central Chile in 1973 and grown at Kew.

Painted in 1989 from a specimen in the Alpine House at the Royal Botanic Gardens, Kew.

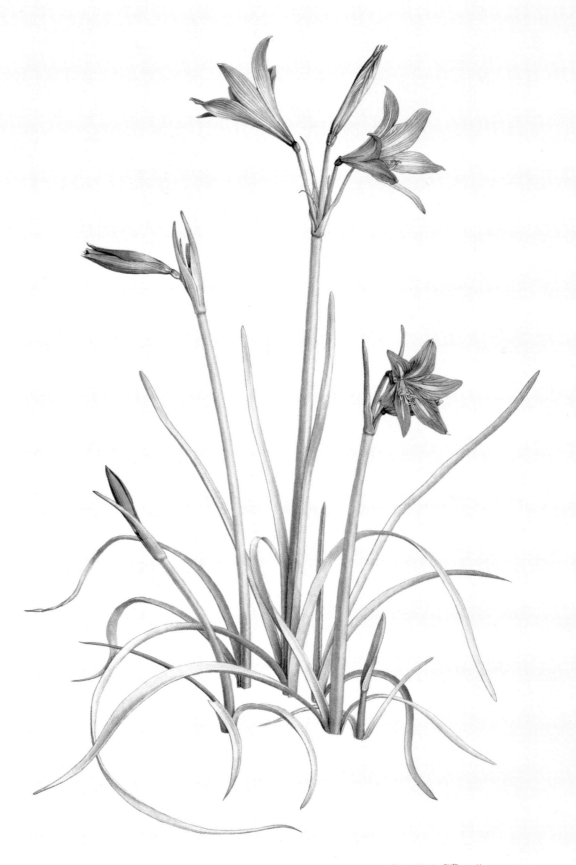

Hippeastrum chilense W.C. + B 4999 John Mark Fothergill 14-7-89

PLATE 17

Echeveria runyonii E. Walther Crassulaceae

ARTIST: MARK FOTHERGILL

The name *Echeveria* was bestowed in 1828 on a predominantly Mexican genus by Augustin Pyramus de Candolle to honour a botanical artist, Echeverria, who would otherwise be forgotten. In 1787 King Charles IV of Spain issued a Royal Order appointing a Spanish physician, Martin de Sessé (1751–1808), as director and Atanasio Echeverria and Juan Vicente de la Cerda as artists with the task of collecting, describing and illustrating the natural products of Mexico. In 1790 enthusiastic José Mariano Moziño (1757–1820), usually called Mociño, joined them. They made numerous arduous exploratory journeys. In 1803 Sessé and Mociño sailed, with their collections, to Spain but they received there no help whatever for publishing their work. Sessé died in 1808. Mociño, disappointed, frustrated, reduced to beggary, physically infirm and almost blind but zealously treasuring some 2,000 illustrations, made his way to Montpellier. The celebrated Swiss professor A. P. de Candolle befriended him and founded at least 270 new species based on those drawings. Then Mociño, a sick man, asked for the drawings to be given back. De Candolle, with the help of 120 talented ladies of Geneva, had them copied in ten days! Mociño then took the originals to Barcelona but died shortly afterwards. They disappeared into private hands and their survival remained unknown until in 1981 the Hunt Institute for Botanical Documentation in Pittsburgh acquired them from a Barcelona family. Thereby the artistic skill of Echeverria, which de Candolle had admired, again became evident.

The precise origin of *Echeveria runyonii* is unknown. It was introduced into cultivation in the United States by Robert Runyon (b. 1881) sometime before 1928 from a garden at Matamans, Tamaulipas, Mexico, but was not described as a new species until 1925. It forms a rosette of very glaucous leaves 6–8 cm ($2\frac{1}{2}$–$3\frac{1}{4}$ in.) long from which arises a flowering stem 15–20 cm (6–8 in.) high with many-flowered racemes of almost pink flowers.

Painted in 1989 for an exhibition in the Kew Gardens Gallery from a specimen in the tropical collection of the Royal Botanic Gardens.

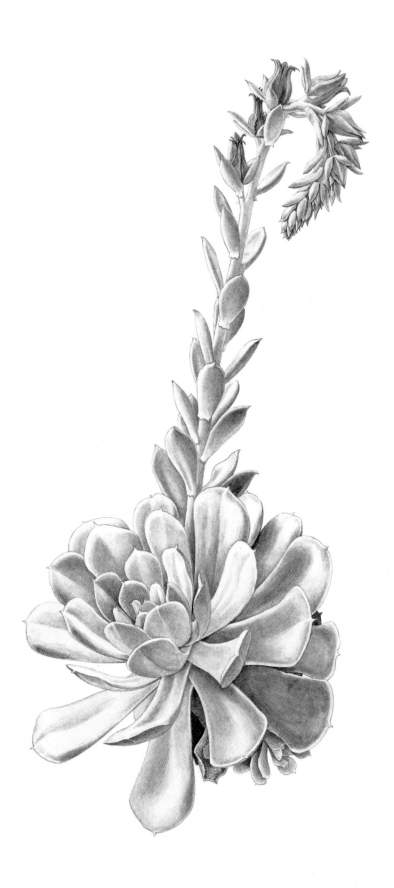

Echeveria runyonii John Mark Fothergill 20-8-89

PLATE 18

Iris Hybrid Iridaceae

ARTIST: VICTORIA GOAMAN

Iris is a genus of manifold diversity with possibly 300 species and a multitude of garden hybrids, which have evolved into distinctive groups of species recognized by both gardeners and botanists. These groups have been distinguished botanically as subgenera, sections and series and horticulturally as 'Bearded Irises', 'Evansia Irises', 'Juno Irises', 'Reticulata Irises' etc. The most important of them for garden purposes is the Pogon or Bearded group (subgenus *Iris* section *Iris*). This includes the sturdy garden irises with thick creeping rhizomes, clustered large leaves, tall stems and large flowers with a beard (a band of hairs) on top of the falls (the lower part of the flower). The type of these is the commonly grown *Iris germanica*, a long-cultivated plant of doubtful origin, apparently not known in a truly wild as distinct from a naturalized state.

The plant figured here is an old hybrid of the *germanica* group having much in common with *I. trojana* of Asia Minor.

Painted from a plant growing in the artist's garden in London.

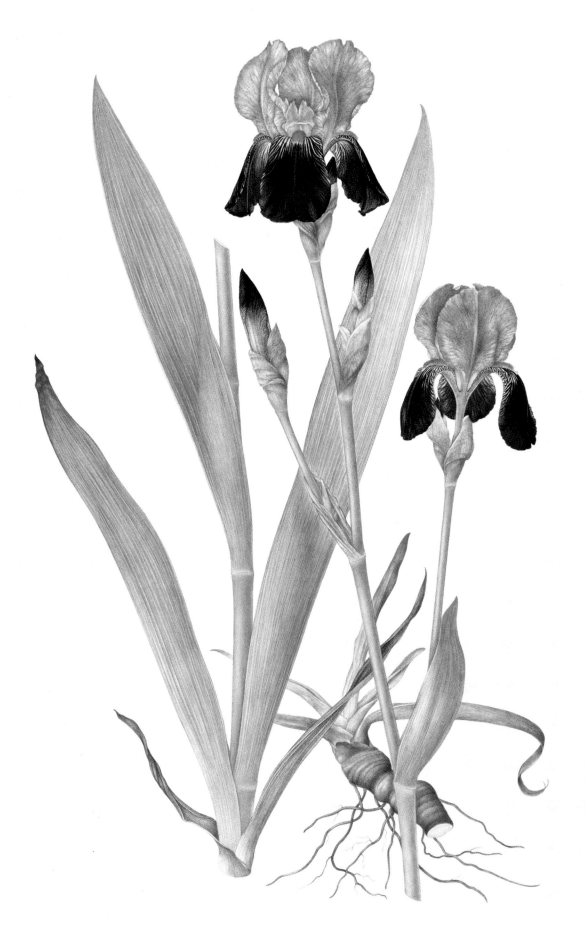

PLATE 19

Three Spring Flowers

ARTIST: VICTORIA GOAMAN

The wild daffodil, *Narcissus pseudonarcissus* Linnaeus, has a wide distribution as a native species in England and Wales but has often been planted in parks and then become naturalized. Hybridization between this and related species followed by further crossing and selection has resulted in an enormous number of garden forms of more robust growth, with taller stems and larger flowers of more varied colours, which have superseded it in most gardens, but it remains an attractive and graceful plant. The long tube (corona) is a darker yellow than the spreading segments. Outside Britain it has a wide range in western Europe. Herbalists in the 16th and 17th centuries distinguished as *Narcissus*, 'true Daffodils', those with a small cup or corona, eg in *Narcissus poeticus*, and as *Pseudonarcissus*, 'bastard Daffodils', those with a long tube or trumpet, whence the paradoxical name *Narcissus pseudonarcissus*.

The Lesser Celandine, *Ranunculus ficaria* Linnaeus (left) with its bright yellow many-petalled starry flowers open in full sunshine make it a conspicuous early plant; as William Turner said in 1548, 'it is one of the fyrst herbes that hath floures in the spring.' The leaves, unlike those of most buttercups, are heart-shaped, to 4 cm ($1\frac{1}{2}$ in.) broad; the flowers about 3 cm ($1\frac{1}{4}$ in.) across, have three sepals and up to twelve petals. On account of these characters it has often been placed in a genus by itself as *Ficaria verna* Hudson. The numerous storage roots are thick and somewhat club-shaped, suggesting haemorrhoids (at one time called 'figs') to early herbalists, whence the 16th-century names 'Fygwort' or 'Figworte' and 'Pyleworte' (Pilewort) attested by William Turner and Henry Lyte.

The Primrose, *Primula vulgaris* Hudson (*P. acaulis* (Linnaeus) Hill) (right) occurs throughout the British Isles, although much diminished or exterminated in many localities by uprooting. The pale yellow blooms arise singly out of a rosette or a tuft of softly hairy leaves. The sticky seeds attract ants which take them out of the capsule and thus distribute them. In south-eastern Europe forms with pink flowers predominate.

Painted from plants growing in the wild.

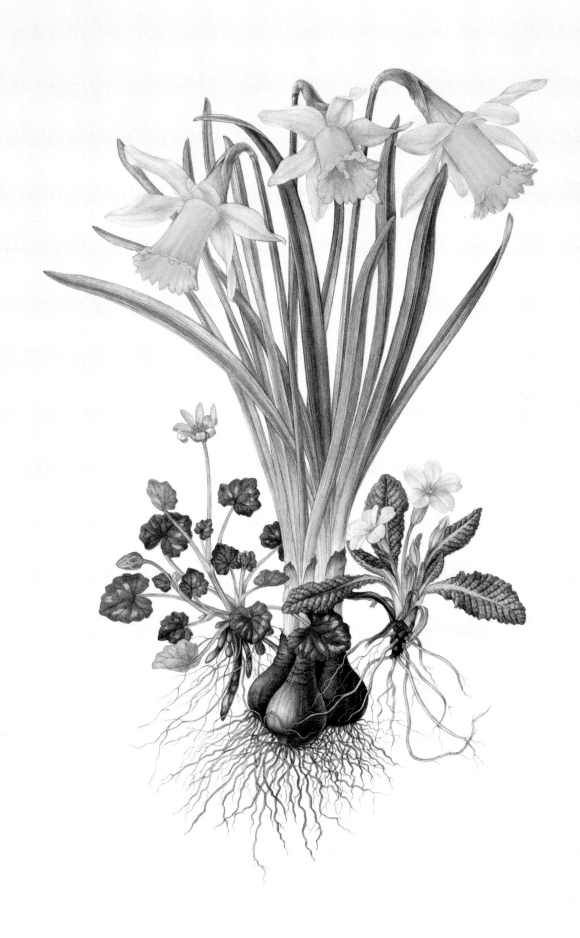

PLATE 20

Geum rivale Linnaeus Rosaceae

ARTIST: VICTORIA GOAMAN

Of the sixty-five species belonging to the genus *Geum*, only two occur in the British Isles. *Geum urbanum* L., variously known as Wood Avens, Common Avens, Herb Bennet and Blessed Herb, has erect flowers with spreading green sepals and spreading yellow petals and grows in well-drained places, such as hedgebanks, wood margins and gardens. *Geum rivale*, Water Avens, has drooping bell-shaped flowers with erect brown or purple sepals and erect usually reddish-veined yellowish petals; it prefers moister places, such as damp meadows and near streams, whence the epithet *rivale* (pertaining to brooks). Where the two species grow near one another, cross-pollination by bees often produces hybrids, of which some are more attractive than either parent.

Painted from plants in the artist's garden.

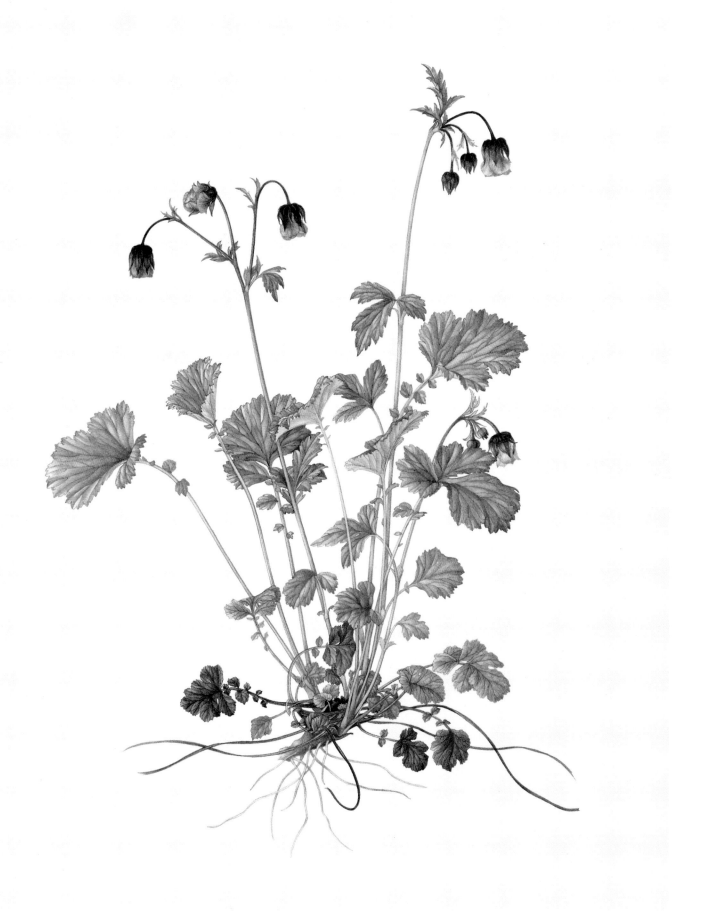

PLATE 21

Passiflora mollissima (Kunth) L. H. Bailey | Passifloraceae

ARTIST: MARY GRIERSON

The genus *Passiflora*, comprising more than 350 American species, is one of the largest and most interesting genera in warm and tropical America with several species now widely cultivated throughout the tropics for their ornamental flowers and edible fruits. Over many years a genus founded by Antoine L. de Jussieu with the name *Tacsonia* (a latinization of the Peruvian name of a species) was kept separate from *Passiflora* but the two are now united.

Passiflora mollissima was discovered by the intrepid explorers of Latin America, Alexander von Humboldt (1769–1859) and Aimé Bonpland (1773–1858), on their American expedition from 1799 to 1804 and was named *Tacsonia mollissima* with reference to the soft hair-covering on its stems and the undersides of its leaves. It is now known to occur in Venezuela, Colombia, Ecuador and Peru. The pendulous flowers about 6–7.5 cm ($2\frac{1}{2}$–3 in.) across have a tube 6.9 cm ($2\frac{1}{2}$–$3\frac{1}{2}$ in.) long and spreading or recurving pink and white sepals. These are followed by elongated yellow fruits 6 cm ($2\frac{1}{2}$ in.) long, which have led to its being called the 'Banana Passionfruit'. It is an attractive plant but nevertheless a danger to the native flora wherever it is introduced, for example in Hawaii where it smothers trees and shrubs by its exuberant strong growth.

For the origin of the names *Passiflora* etc, see plate 22.

Painted in 1989 from material collected on the island of Kauai, Hawaii.

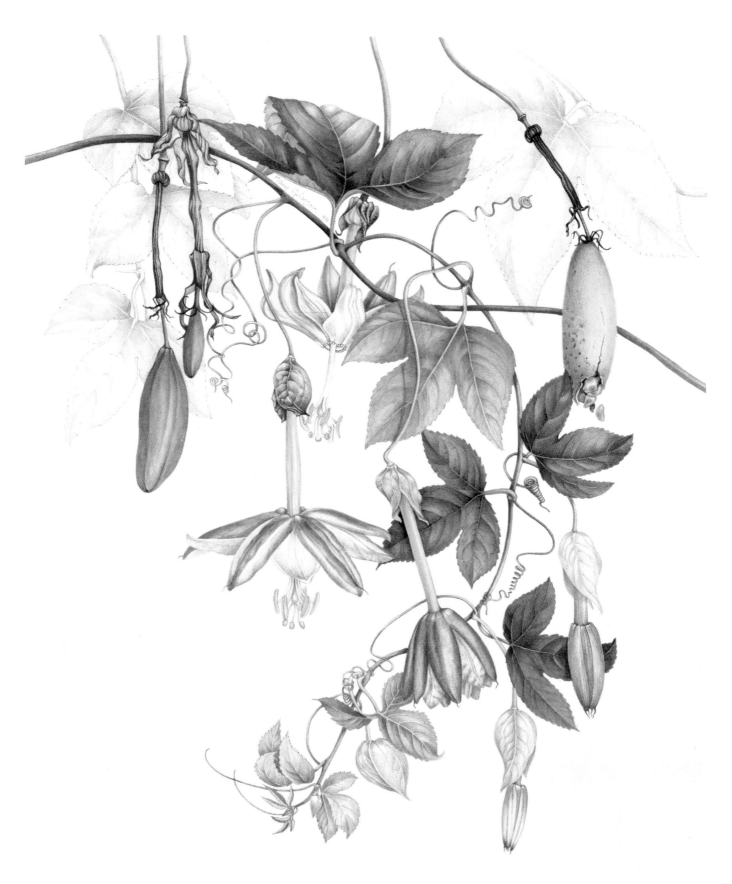

Passiflora Mollisima? 13×17 Mary Grierson February, 1989

PLATE 22

Passiflora edulis Sims Passifloraceae

ARTIST: MARY GRIERSON

Fruits of *Passiflora edulis*, often known as the Purple Granadilla, provide passionfruit juice. Within the hard shell are numerous seeds each covered with a juicy pulp. The species is of Brazilian origin but the demand for passionfruit has led to its being widely cultivated in warm countries, for example in southern California, Mexico, Hawaii and Australia, and in some it has run wild. The genus *Passiflora* comprises about 400 species, all climbers with long coiling tendrils, but *P. edulis* is economically the most important, even though a few others, among them *P. quadrangularis, P. laurifolia* and *P. ligularis*, have esteemed fruits. The Spanish name 'Granadilla' means a 'small pomegranate', the seeds of the pomegranate, *Punica granatum*, being likewise enveloped in juicy pulp.

The name *Passiflora* is a variant of the name *Flos Passionis*, which derives from the theological interpretation given to the extraordinary structure of the flower by Spanish missionaries in the New World. They believed that God had created such a wonderful flower to convert heathen native Indians to Christianity, its parts symbolizing the Passion or suffering of Christ upon the cross by representing the crucifixion. Thus the three styles represented the three nails, two for the hands, one for the feet; the five anthers, five wounds; the corona, the crown of thorns and the scourges used before crucifixion. Theological writers found other resemblances; thus the three-lobed leaves of *P. caerulea* represented the Trinity, the climbing habit the aspirations of Christians for Heaven.

Painted in 1989 from material collected on the island of Kauai, Hawaii.

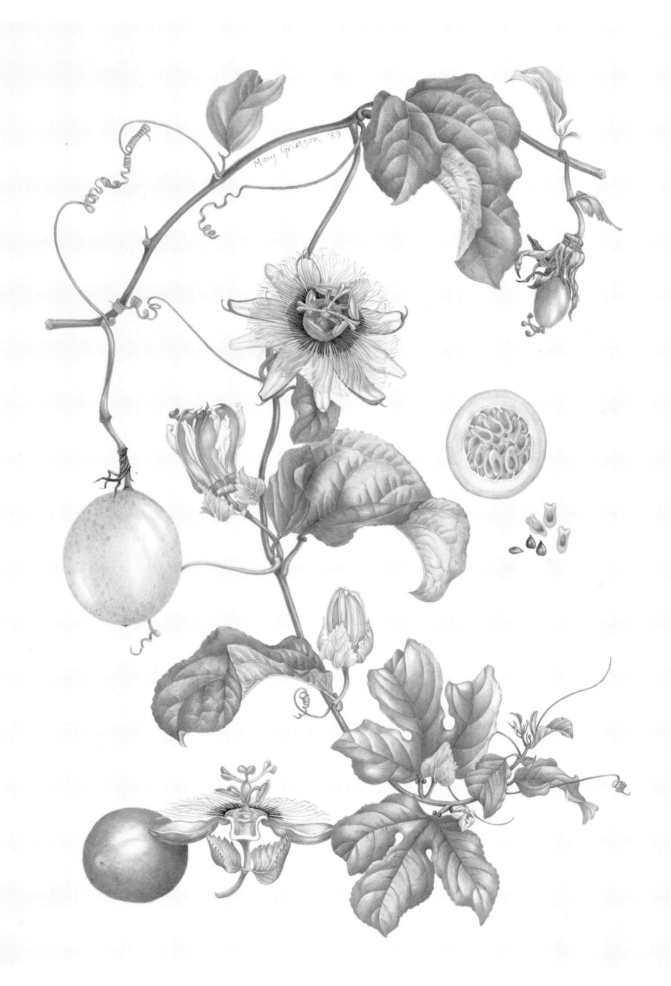

PLATE 23

Cibotium barometz (Linnaeus) J. Smith Thyrsopteridaceae

ARTIST: MARY GRIERSON

No fern has given rise to a more fantastic medieval belief, that of the vegetable lamb of Tartary, than *Cibotium barometz*, even though cotton (*Gossypium*), by producing vegetable wool, contributed to the legend of a plant rooted in the ground and supporting on a thick flexible stalk a lamb able to graze on the surrounding vegetation. A figure of this marvellous plant-animal occurs on the frontispiece of John Parkinson's *Paradisus terrestris* (1629).

Cibotium barometz belongs to a group of tree-ferns but, instead of a trunk, possesses only a short basal stock thickly covered with long shining hairs like brown wool, from which arise elegant much divided leaves nearly 2 m (6 feet) long. It ranges from Assam to Malaya and southern China. From the hairy stock the Chinese have long made lamb-like toys, taking a piece with four leaves, cutting their stalks short to resemble legs and trimming the piece itself to resemble a lamb's body and head, on which two beads or seeds are inserted for eyes. Reversed, so that the legs support the woolly body, this then becomes a 'vegetable lamb'. Cotton, called in German 'Baumwolle' (tree-wool), being known to grow on a plant, made plausible the legend having its origin in these toys.

Painted in the 1970s for the World Wildlife Fund from a specimen grown at the Royal Botanic Gardens, Kew.

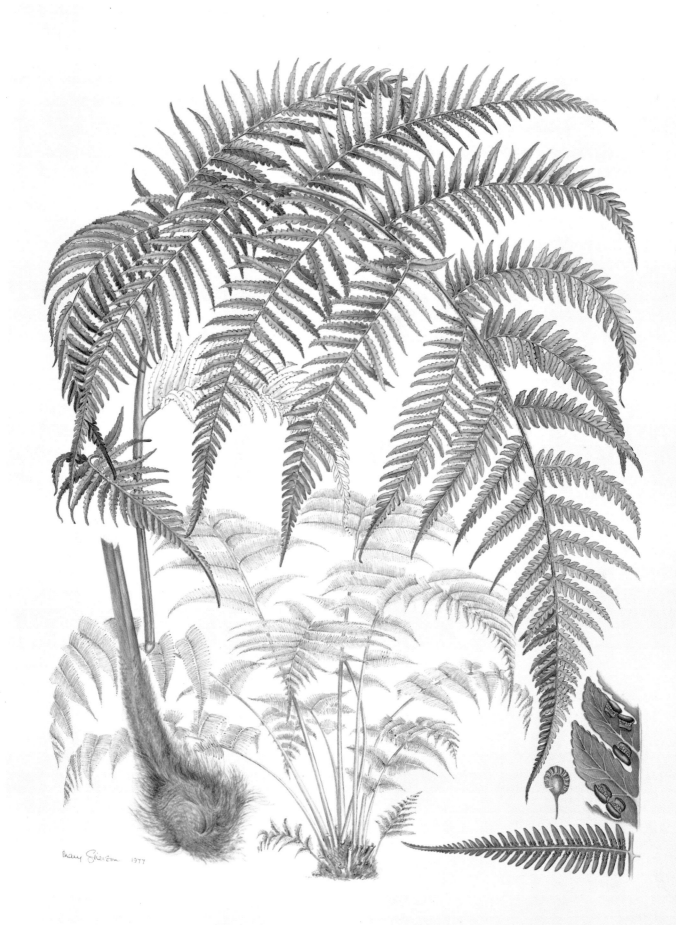

Mary Grierson 1977

PLATE 24

Campsis radicans (Linnaeus) Seemann Bignoniaceae

ARTIST: MARY GRIERSON

The high energy expenditure of humming birds, with about fifty wing-beats a second, makes them dependent upon an abundant supply of nectar as well as of flying insects. To meet their needs various unrelated American plants have evolved along the same lines in return for pollination; they have developed red or yellow conspicuous flowers, with a nectar-containing tube, held away from or above foliage which might impede the hovering bird's wings. One such plant is *Campsis radicans*, the Trumpet-creeper or Trumpet-flower. Originally named *Bignonia radicans* Linnaeus, this grows wild in thickets and up into trees from New Jersey and Pennsylvania southward to Florida and Texas and was introduced into Europe before 1640. Unlike *Bignonia*, typified by *B. caspreolata* Linnaeus, which has leaves with two leaflets and a tendril, *Campsis radicans* has leaves with four or five pairs of leaflets and a terminal leaflet but no tendrils; it climbs like ivy, holding itself against tree-trunks and in cultivation against sunny walls by aerial rootlets, whence the epithet *radicans*, 'rooting'. The generic name *Campsis*, from Greek *kampsis*, 'bending', refers to the curved stamens of the type-species, the Chinese *C. grandiflora* (Thunberg) K. Schumann. This has hybridized with *C. radicans*, producing the hybrid group called *C* × *tagliabuana* (Visiani) Rehder.

Painted in 1987 for inclusion in a book on plants growing in English gardens in the 17th century, An English Florilegium. The Tradescant Legacy *(1987). With text by W. T. Stearn and C. Brickell.*

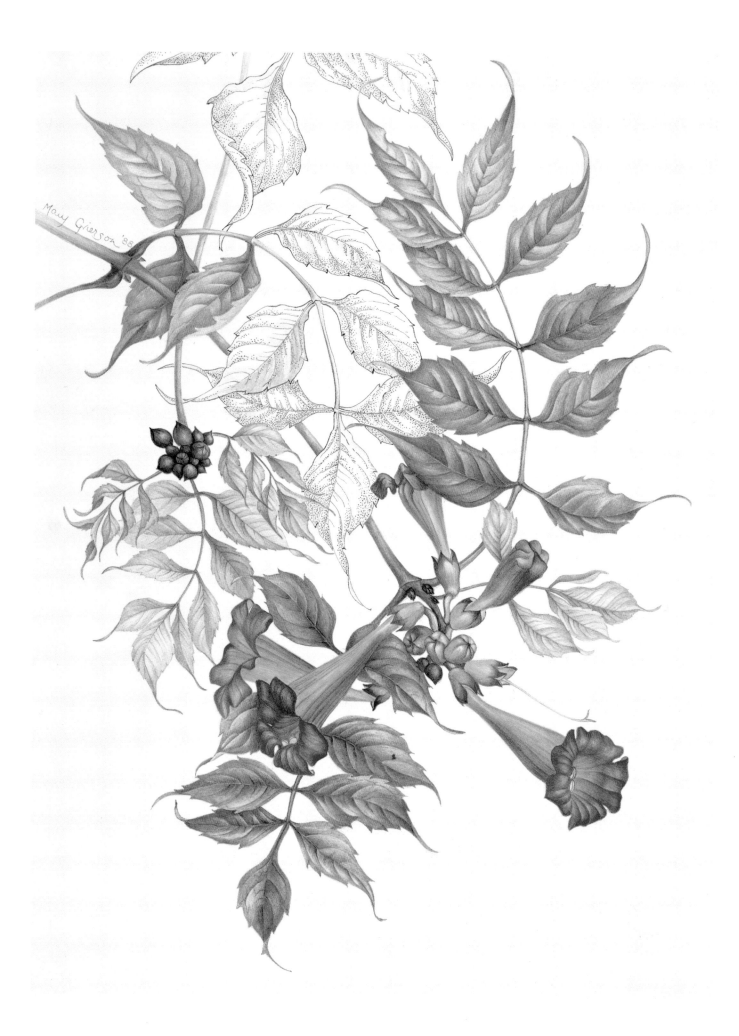

PLATE 25

Arbutus unedo Linnaeus Ericaceae

ARTIST: MARY GRIERSON

In the British Isles the Strawberry Tree grows wild only among rocks in the counties of Kerry, Cork and Sligo, thus confined to a small area in south-western Ireland. Here it forms trees up to 12 m (36 feet) high with reddish bark, evergreen leaves and small white flowers in hanging clusters in late autumn or early winter. They resemble those of lily-of-the-valley (*Convallaris majalis*) in shape. The globose red fruits of tempting strawberry-like appearance but not taste, being almost flavourless, take about a year to ripen; thus the tree is both in flower and fruit at the same time.

This species is essentially a Mediterranean one, which occurs in maquis from Greece over Italy, southern France and Spain to Portugal and then extends northward along the Atlantic Coast of France from Brittany to southern Ireland. There it is a relict species, a survivor from a period when a warmer climate favoured its spread. Nevertheless it is quite hardy in England. *Arbutus* and *unedo* are the Latin names used by classical authors for this tree.

In nature *A. unedo* hybridizes with an eastern Mediterranean species, *A. andrachne* L. which flowers usually in the spring, but their blooming periods may overlap. The hybrid is known as *A × andrachnoides* Link.

Painted in October 1988 from a specimen in a garden in Richmond, Surrey.

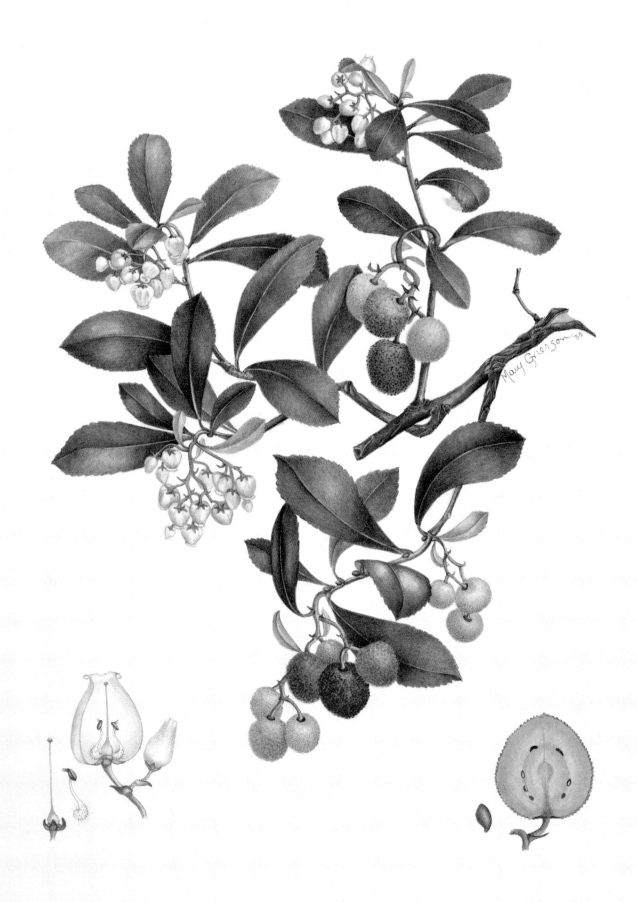

PLATE 26

Helleborus lividus Aiton ex Curtis Ranunculaceae

ARTIST: MARY GRIERSON

Helleborus lividus is a species known only from the Balearic island of Majorca; its close ally *H. argutifolius* Viviani occurs only on Corsica and Sardinia. The leaves in both have three rather leathery leaflets, which are almost smooth-edged and with an evident network of whitish veins on the upper side in *H. lividus* but markedly spine-edged and with green veins on the upper side in *H. argutifolius*. The wide-open saucer-shaped flowers, about 2.5–5 cm (1–2 in.) across, are greenish suffused with pale purple outside in *H. lividus* but completely pale green in *H. argutifolius*. Under cultivation in southern England *H. argutifolius* has proved completely hardy out-of-doors but *H. lividus* is very liable to damage by frost.

Painted in 1986 to illustrate a book Hellebores *(1989)* by Brian Mathew.

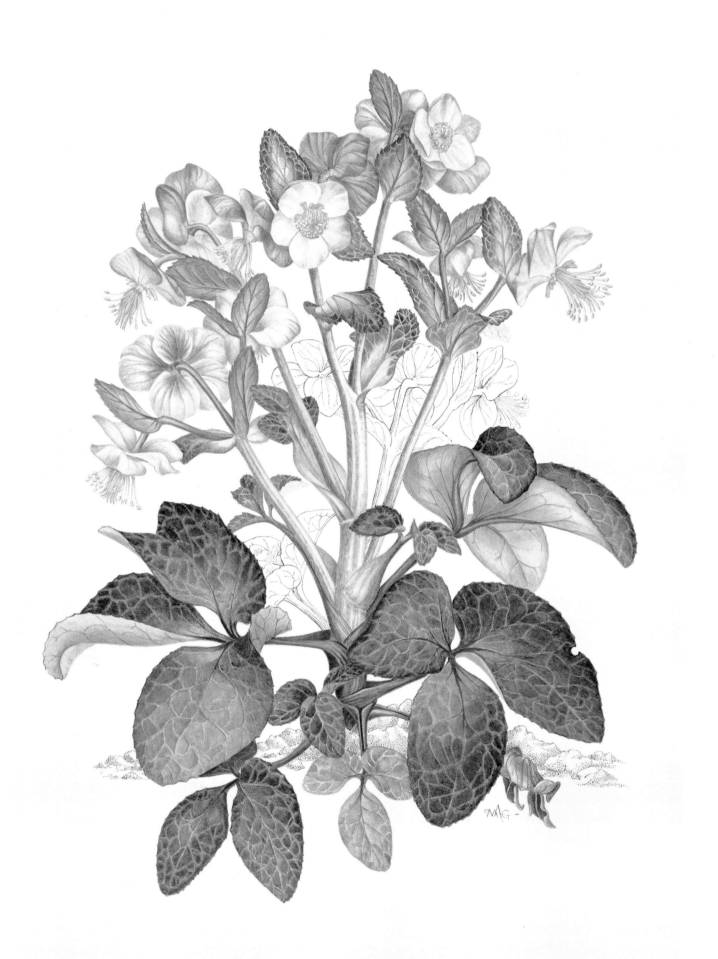

PLATE 27

Ipomoea purpurea (Linnaeus) Lamarck Convolvulaceae

ARTIST: JOSEPHINE HAGUE

Ipomoea is a very large and diverse genus, with possibly 500 species, of world-wide range. They vary in habit from creeping plants such as *I. pes-caprae* (Linnaeus) R. Brown, widespread on sandy tropical shores, to tall shrubs such as *I. fistulosa* Choisy. Economically the most important is the Sweet Potato, *I. batatas* (Linnaeus) Lamarck, cultivated throughout the tropics and subtropics for its edible root-tubers. Some, e.g. *I. purga* (Wenderoth) Hayne, Jalap, and *I. orizabensis* (Pellett) Steudel, Scammony, are a source of purgatives. Many are twining climbers, a few night-blooming with white scented flowers, such as *I. alba* Linnaeus and *I. tuba* (Schlechtendal) D. Don, formerly placed in a separate genus *Calonyction*. However, most species open their flowers early in the morning, hence the name 'Morning-glory', and by the afternoon in hot weather the flowers wither. *Ipomoea purpurea*, a native of tropical America, with blue, purple or pink flowers, is probably the most widely grown of the annual twining Morning-glories.

Painted in 1980 in a group of eight paintings, 'Country Flowers', for the Ariel Press.

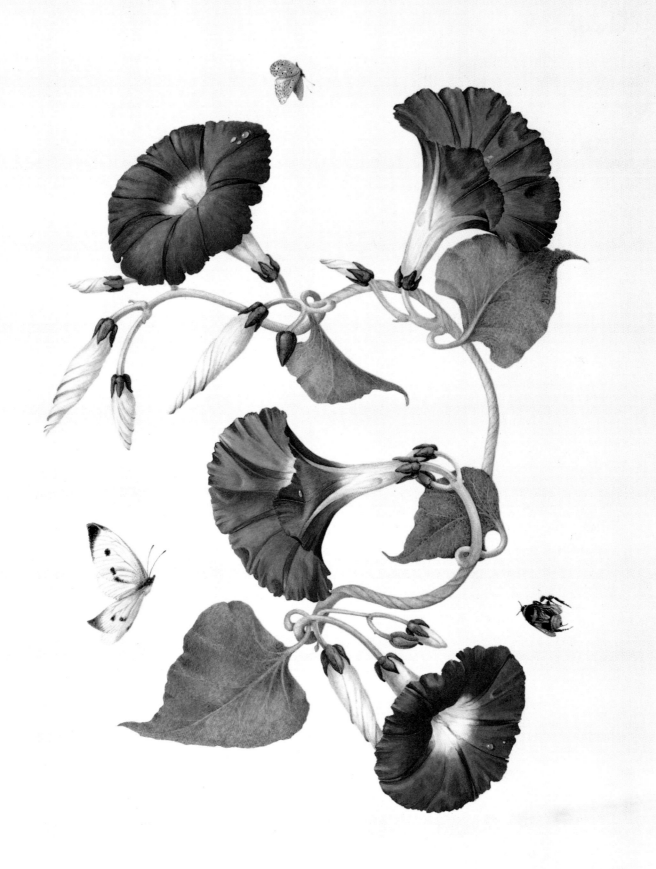

Clematis × *jackmanii* Dombrain Ranunculaceae

ARTIST: JOSEPHINE HAGUE

George Jackman senior (1801–67) was a successful nurseryman at Woking, Surrey, where his father William (1763–1840) had founded a nursery in 1810. He and his son George Jackman junior (1837–87) became interested in raising *Clematis* hybrids using the European *C. viticella* L., the Chinese *C. lanuginosa* Lindley introduced in 1850 and the hybrid *C.* × *eriostemon* 'Hendersonii' (*C. integrifolia* × *C. viticella*). Their seedlings flowered in 1862 and a selected one evidently derived from *C. lanuginosa* × *C. viticella* was named *C.* × *jackmanii* by Dombrain in 1865. This has remained a popular garden plant.

 C. × *jackmannii* was the forerunner of at least 35 other meritorious hybrids raised by George Jackman junior. He published, in collaboration with Thomas Moore, *The Clematis as a Garden Flower* (1872), the first horticultural book on the genus; the next English work appears to be William Robinson's ambiguously named *The Virgin's Bower* (1912).

 The butterflies are the Large White Cabbage Butterfly (*Pieris brassicae*) and the Peacock Butterfly (*Inanchis io*).

Painted in 1980 in a group of eight paintings, 'Country flowers', for the Ariel Press.

94

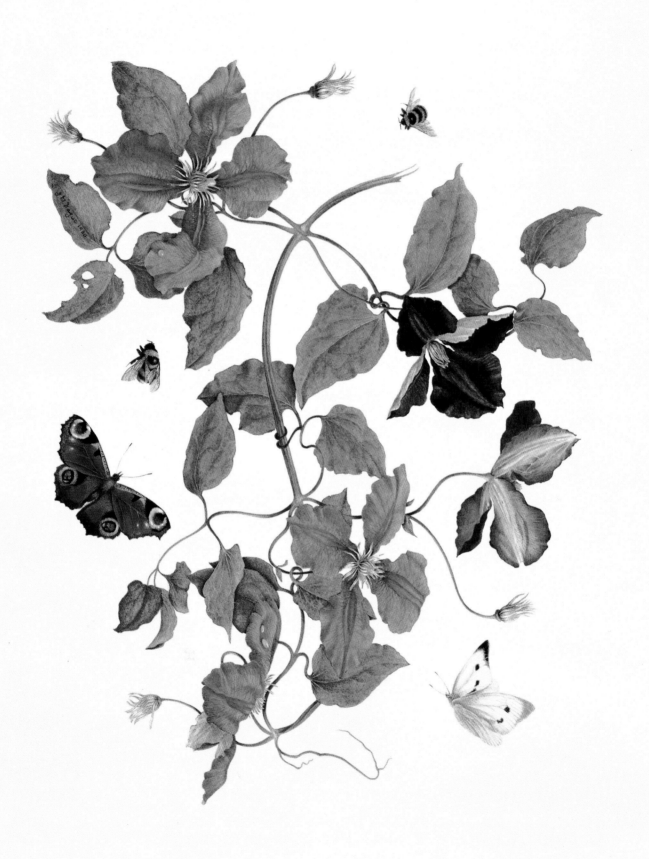

PLATE 29

Iris pseudacorus Linnaeus — Iridaceae

ARTIST: JOSEPHINE HAGUE

Widespread in the British Isles and likewise over most of Europe and western Asia in moist habitats, such as boggy ground, freshwater marshes, the sides of ponds, lakes and slow-moving rivers, the Yellow Iris with its large yellow flowers held on branched stems about 1 m (3 feet) high is one of our most conspicuous and unmistakable wildflowers. The buoyant flattened seeds float into suitable habitats.

The curious epithet *pseudacorus* has a herbalistic background. The Ancient Greeks used the names *akoros* or *akoron* (Latin *acorus* or *acorum*) and *kalamos euodes* (Latin *calamus odoratus*) for a plant with aromatic iris-like rhizomes imported from Asia, now called *Acorus calamus* L., Sweet Flag, which was not introduced into European cultivation until 1567. The similar-looking rhizome of the native Yellow Iris was sometimes unscrupulously substituted for it. William Turner warned in 1548 that 'Acorus groweth not in England, wherefore they are farre decpued [deceived] that use the yelowe flourdeluce, which some call gladen, for Acorus.' Hence the old herbalists called the Yellow Iris *Acorus adulterinus* and Linnaeus called it *pseudacorus* (i.e. false acorus).

The dragonfly is the Emperor Dragonfly (*Anax imperator*).

Painted by the Lily Pond at Liverpool University Botanic Gardens, Ness.

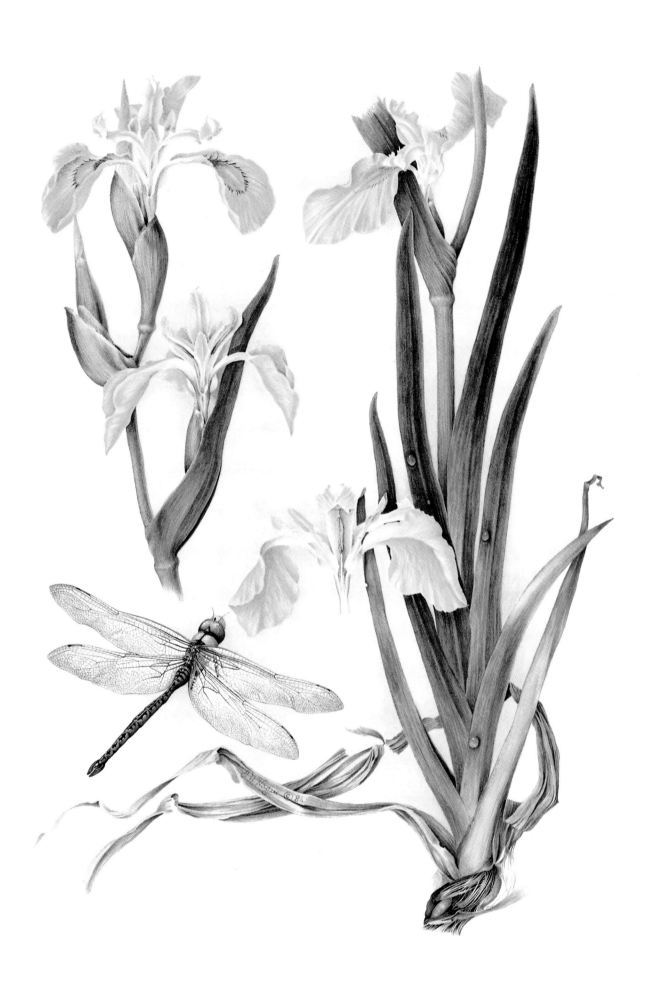

PLATE 30

Leucocoryne species Liliaceae (Alliaceae)

ARTIST: CHRISTABEL KING

The twelve accepted species of *Leucocoryne* inhabit the mountains of Chile in western South America and are bulbous plants with narrow basal leaves and conspicuous flowers in umbels. Three fertile stamens lie deep within the flower-tube, which is much shorter than the widely spreading segments, but three sterile stamens (staminodes) project from the mouth of the tube. In the type plant, introduced into cultivation in 1825, the bulbs having been collected in the Chilean mountains between Santiago and Valparaiso, the three staminodes were white and thus led John Lindley in 1830 to coin the generic name *Leucocoryne*, from Greek *leukos*, 'white', *koryne*, 'club'. In most species the staminodes are yellow. *Leucocoryne ixioides*, when re-introduced from Chile by Clarence Elliot, was then given the name 'Glory of the Sun'.

The left hand plant is *Leucocoryne purpurea* F. Philippi; the middle-left, with white flowers, *L. coquimbensis* F. Philippi var. *alba* Zoellner; the middle-right, with large blue and white flowers, *L. coquimbensis* F. Philippi; and the right-hand one probably *L. pauciflora* R. W. Philippi.

Painted in 1984 from plants in the collections of the Royal Botanic Gardens, Kew for an exhibition that year in York.

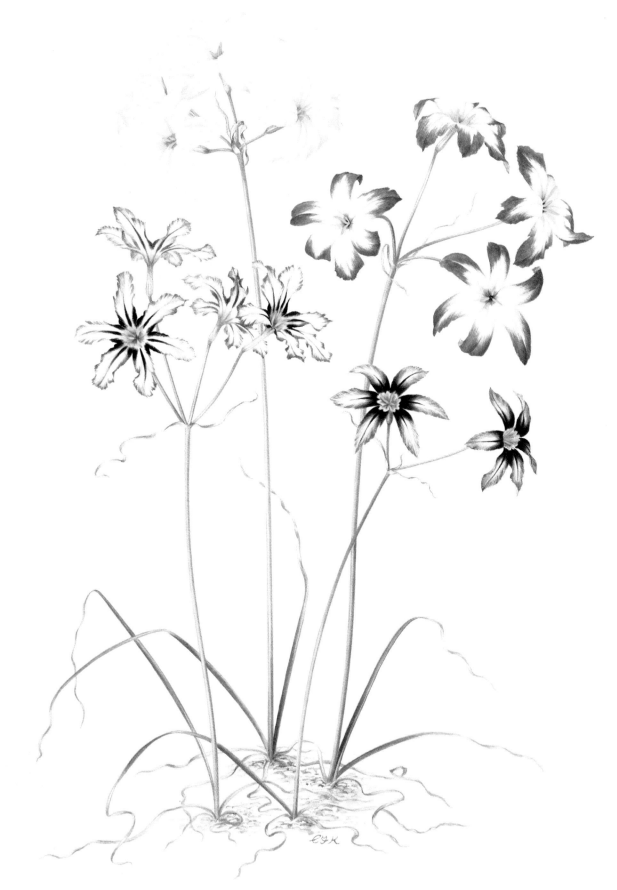

PLATE 31

Calochortus species Liliaceae (Calochortaceae)

ARTIST: CHRISTABEL KING

Calochortus is a genus of bulbous plants, some known as 'Mariposa Lilies', with about sixty species extending from British Columbia down western North America to California, and thence to Guatemala. Their leaves are narrow, their flowers elegant and usually conspicuous, whence the generic name coined by Pursh from *kalos* 'beautiful', *chortos*, 'grass, herb'. Both the species illustrated here were discovered in California by the intrepid Scottish plant-collector David Douglas (1799–1834) when gathering bulbs, seeds and specimens for the Horticultural Society of London in 1831. The flowers have three small outer segments (sepals) and three large inner segments (petals) with near the base a gland which varies greatly in form from species to species.

Calochortus venustus Bentham is a very variable species with red, purple, yellow or white petals, the gland almost circular.

Calochortus luteus Lindley, the Yellow Mariposa, always has yellow petals, often marked with reddish brown lines, the gland oblong or crescent-shaped. The plant illustrated was grown at Kew from seed collected in Colusa County, California at 225 m (740 feet).

Painted in 1984 from plants in the collections of the Royal Botanic Gardens, Kew for an exhibition that year in York. Not previously reproduced.

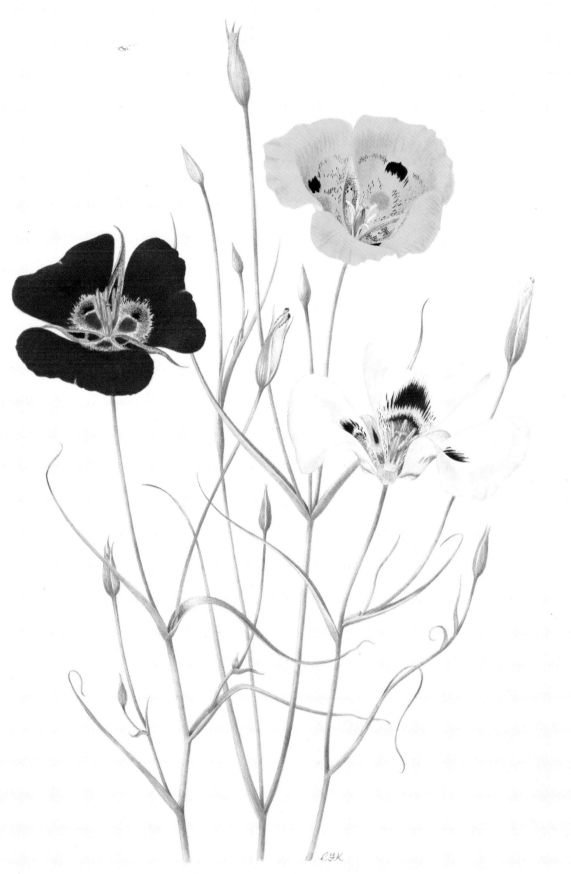

Calochortus venustus, red-white form 365-78-03482, C. luteus 461-71-06288
California, cult. Alpine Dept., RBG Kew, May 1986

PLATE 32

Calceolaria crenatiflora Cavanilles Scrophulariaceae

ARTIST: CHRISTABEL KING

The expedition of two ships, the *Descubierta* and *Atrevida* under the command of Alessandro Malaspina, which sailed from Spain in July 1789 on a surveying voyage, was the most expertly planned, well-equipped and brilliantly staffed one ever to leave Spain. Aboard were three naturalists Louis Neé, a Frenchman, who was a skilled artist, Thaddaeus Haenke, a German Bohemian, and Antonio Pineda, a Spaniard. The expedition visited the coasts of Chile (including the island of Chiloe), Peru, Ecuador, northward to Alaska and across the Pacific Ocean to the Philippines, New Zealand and Australia. Returned to Spain in 1794 after a scientifically highly successful voyage, Malaspina, the victim of a court intrigue, suffered eight years of imprisonment. Thus lack of appreciation in Spain ruined the whole enterprise. However, the botanical specimens and drawings made by Louis Neé came into the hands of the Spanish botanist H.J. Cavanilles. Among them, from Santa Clara on the island of Chiloe, was this handsome *Calceolaria* which Cavanilles named *C. crenatiflora* in 1799.

This species makes a basal rosette of softly hairy leaves from which arise stems to 30–90 cm (1–2½ feet) high with loose clusters of large yellow flowers spotted red on the pouched lower lip. Introduced into cultivation about 1830, it became the parent of the commonly grown florist's calceolarias used in glasshouse decoration and summer bedding. The hybrid group of which it is one parent, another being *C. corymbosa*, has received the name *C.* × *herbeohybrida* Voss.

Painted in 1984 from plants in the collections of the Royal Botanic Gardens, Kew for an exhibition that year in York.

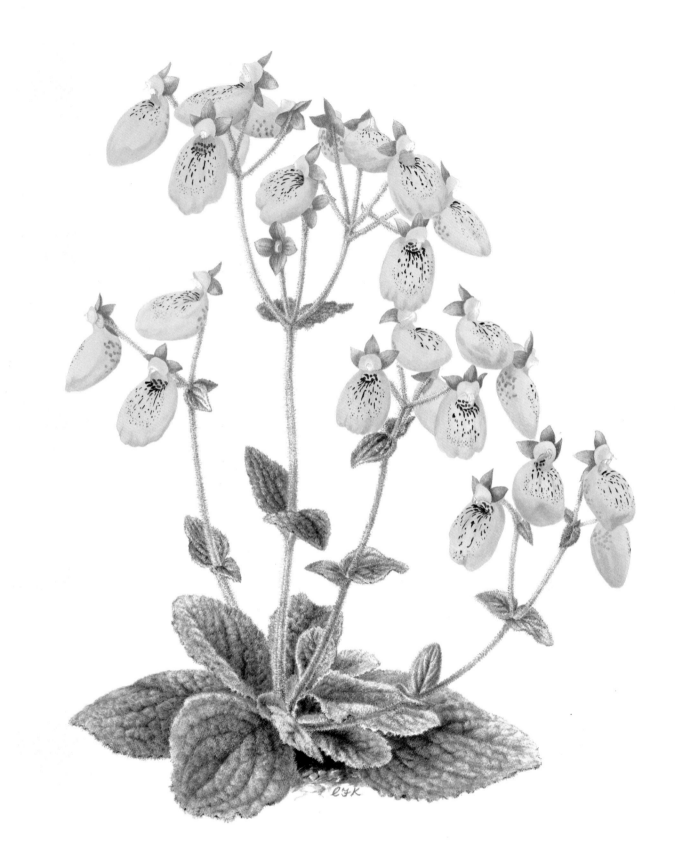

Calceolaria crenatifolia
Cult. Alpine Dept., RBG Edinburgh 1996/1231, Argentina. 23 May 17

PLATE 33

Hippeastrum elegans (Sprengel) H. E. Moore Amaryllidaceae

ARTIST: JOANNA LANGHORNE

Hippeastrum elegans, better known as *H. solandriflorum* (Lindley) Herbert, stands apart from most of the approximately seventy-five species of the genus by its remarkably long pale greenish yellow trumpet-shaped flowers 18–25 cm (7–10 in.). These are borne two to four in an umbel on a stem 45–60 cm ($1\frac{1}{2}$–2 ft) high. The leaves begin to develop as the flower-stems arise and may be up to 45 cm ($1\frac{1}{2}$ ft) long. It was introduced into cultivation from Cayenne, French Guiana, about 1819 and described and illustrated by John Lindley as *Amaryllis solandraeflora*, its long flowers suggesting those of the West Indian *Solandra grandiflora* Swartz (Solanaceae). The species is also known to occur in north Brazil.

Linnaeus included nine species in his genus *Amaryllis* in 1753; these are now placed in separate genera, *Sternbergia*, *Zephyranthes*, *Sprekelia*, *Amaryllis*, *Nerine*, *Crinum*, *Cybistetes*, *Brunsvigia* and *Boophone*. There has been some controversy as to whether his name *Amaryllis belladonna* referred primarily to a South American species known as *Hippeastrum equestre* (Aiton) Herbert (*H. puniceum* (Lamarck) Voss) or a South African species known as *Amaryllis rosea* Lamarck. It has been decided to restrict the name *Amaryllis belladonna* to the South African species. Hence this American species originally named *Amaryllis elegans* is now named *Hippeastrum elegans*.

Painted in August 1984 from material grown at the Royal Botanic Gardens, Kew.

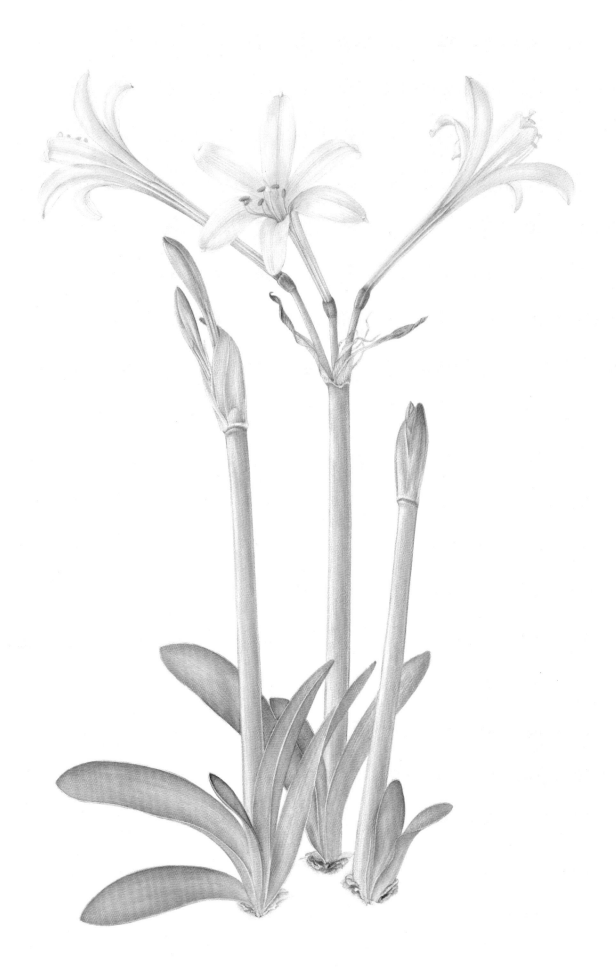

PLATE 34

Iris iberica Hoffmann subsp. *elegantissima* (Sosnowsky) Federow & Takhtajan

Iridaceae

ARTIST: JOANNA LANGHORNE

The Romans and Ancient Greeks used the name 'Iberia' for two widely separated regions, seemingly with as little confusion as there is now between Georgia, USSR and Georgia, USA. Iberia in the west apparently took its name from the river Iberus (now the Ebro) in Spain, but ultimately extended far beyond the Evro valley inhabited by the Iberi. Iberia in the east corresponded largely to modern Georgia in the Caucasus, once a powerful medieval kingdom but later ruined by Mongol, Hun, Turkish and Persian invasions and ultimately annexed by Russia. This annexation led to botanical collecting and introduction of Caucasian plants into cultivation by Germans in Russian employ. Among Caucasian plants thus made known was *Iris iberica* described by Georg Franz Hoffman (1760–1826) from the Tiflis area. This species, which also grows in Armenia and northern Iran, varies considerably. It belongs to the Oncocylus section, a group notoriously difficult to cultivate. Plants of *I. iberica* are about 15–20 cm (6–8 in.) high with distinctly curved leaves. Typical *I. iberica* is replaced in eastern Turkey, Armenia and north-western Iran by subsp. *elegantissima*, growing at about 1000–2000 m (3300–6500 feet). This tends to be taller, with stems 20–30 cm (8–12 in.) high, and to have larger flowers.

Painted in May 1986 as a private commission from a plant collected in eastern Turkey by E. M. Rix.

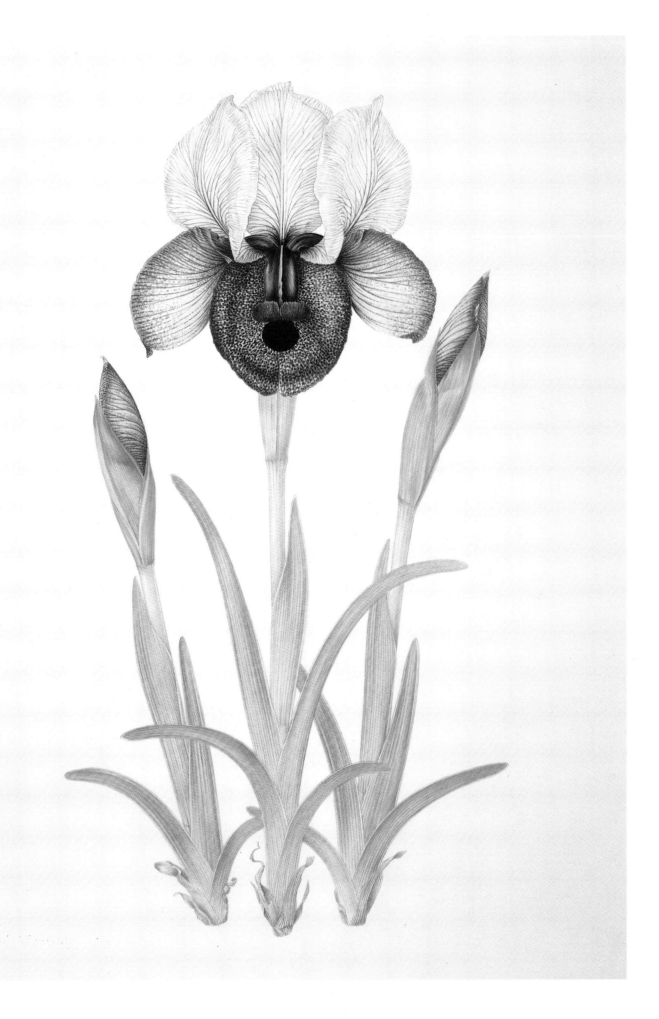

PLATE 35

Paphiopedilum hybrids Orchidaceae

ARTIST: CHERRY-ANNE LAVRIH

The slipper orchids of tropical Asia, now placed in the genus *Paphiopedilum*, when introduced into cultivation during the first half of the 19th century were found to agree so closely in the general form of their flowers with the temperate-zone *Cypripedium calceolus* (plate 5) and its allies that botanists and gardeners referred them to the same genus, *Cypripedium*. John Lindley (1799–1865) in 1842 noted that 'there is something in the habit of the Indian Lady's slippers so peculiar', but not until 1886 did a botanist Ernst E. H. Pfitzer (1846–1906) separate them generically under the name *Paphiopedilum* on account of their evergreen leaves which are not rolled when young. It took orchid-growers unacquainted with the hardy species many years to recognize the validity of this distinction: indeed until about 1970 they kept these glasshouse orchids mostly in *Cypripedium*. Meanwhile in the 1860s John Dominy (1816–91) had begun raising hybrids of *Paphiopedilum* in the nursery of Messrs Veitch of Chelsea and many others have followed his example; thus the named hybrids now vastly exceed in number the accepted wild species, about sixty-five.

The plate here illustrates a few modern cultivars, to which Awards were given by the Royal Horticultural Society in 1988 and 1989.

TOP LEFT *P. hirsutissimum* 'Gaytarn'.
BOTTOM LEFT *P.* Via Chetumal 'André'. A hybrid of *P.* Lalime × *P.* Golden Diana.
TOP RIGHT *P.* Wedding Bells 'Mont Millais'. A hybrid of *P.* Callo-barbatum × *P. sukhakulii*.
BOTTOM RIGHT *P.* Corbiére 'Trinity'. A hybrid of *P.* Spotter × *P.* Personality.

Painted for the Royal Horticultural Society as Award of Merit winners in March 1989, February 1988, November 1988 and January 1989.

PLATE 36

Selenicereus wittii (K. Schumann) Rowley Cactaceae

ARTIST: MARGARET MEE

Sometime before 1900 a German, N. H. Witt, living at Manaus, the capital of Amazonas state in Brazil, noticed an extraordinary cactus with flattened leaf-like but spine-edged stems, at first green then turning crimson, which climbed around the trunks of Amazonian trees. He sent material and a fruit to Karl Schumann (1891–1904), then the foremost botanical expert on the Cactaceae, at Berlin, and introduced it into cultivation there. Schumann described and illustrated it in 1900 as *Cereus wittii* but apparently never saw its flowers, which are rarely produced in gardens, open at night and last only until the next morning. In 1913 the American monographers of the Cactaceae, N. L. Britton (1859–1934) and J. N. Rose (1862–1928), put it in a genus by itself as *Strophocactus wittii*, the generic name from *strophe*, 'turning, revolving, twist', with reference to its appressed stems encircling trees. In 1986 Gordon Rowley transferred it to the genus *Selenicereus*, which includes *S. grandiflorus*, Queen of the Night, and *S. pteranthus*, Princess of the Night. The name *Selenicereus* is from the Greek *selene*, the moon. Margaret Mee first saw this night-flowering cactus in 1964 and later on three other occasions but it was always flowerless. Not until May 1988, the month of her 79th birthday and within eight months of her tragic death, did she have the excitement, during a night-long vigil, of seeing its big starry ephemeral flowers completely open and of painting them by torchlight from the upper deck of a boat within a flooded forest on the Rio Negro. The flowers are sweetly fragrant. This triumph crowned Margaret Mee's career as a botanical artist.

Sketched in 1988 from a boat on the Rio Negro, Brazil, at the first night-flowering of this Amazon moonflower to be witnessed by the artist.

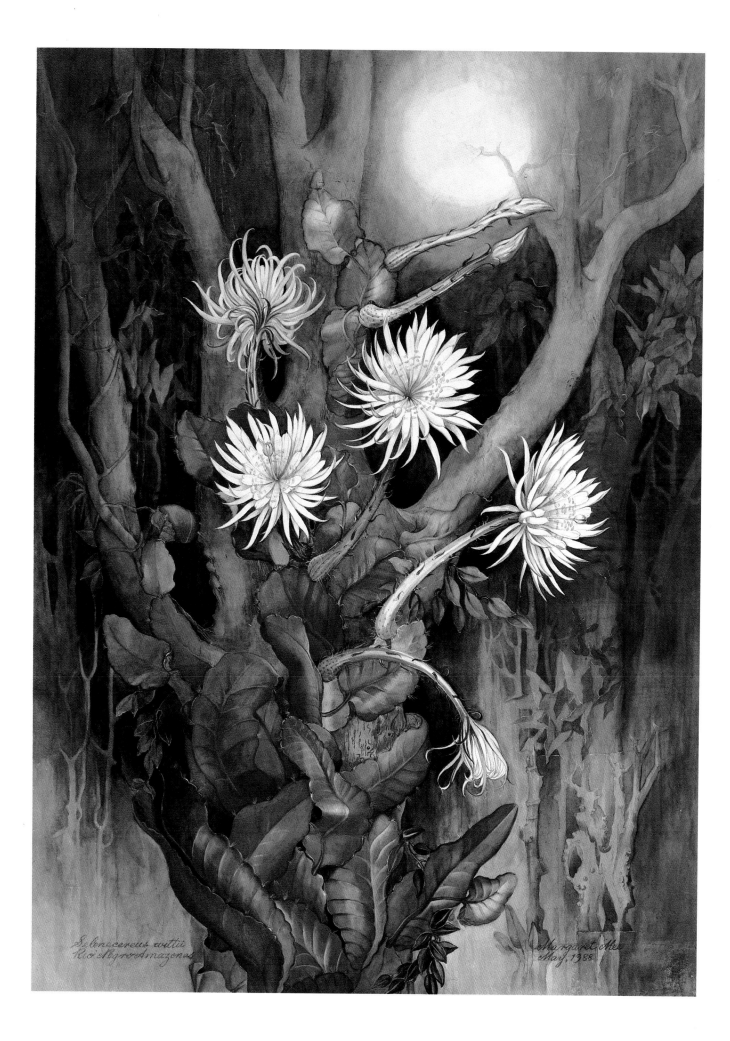

Selenecereus wittii
Rio Negro Amazonas

Margaret Mee
May, 1988

PLATE 37

Catasetum saccatum Lindley Orchidaceae

ARTIST: MARGARET MEE

The fifty species of the tropical American genus *Catasetum* divide into two groups, those with normal hermaphrodite flowers, i.e. with both male and female organs in the same flower, and those with flowers either male or female and then usually borne on different plants, rarely on the same plant. The male and female flowers are so different and extraordinary that even the great Victorian orchidologist John Lindley referred them to different genera!

Catasetum saccatum was introduced into English gardens from Guyana (British Guiana) sometime before 1840 by the firm of Conrad Loddiges and Son. A very variable species, it is now known to occur in the Guianas, Brazil and Peru. The male flowers have on the lower lip, as described by Lindley in 1841, 'a callous perforation kidney-shaped in front, slightly two-lobed and warted; this perforation opens into a small bag-shaped chamber, which projects below the underside of the bag.' Lindley knew only the male plant. Male flowers, when fully open about 10 cm (4 in.) across, are predominantly brown or dull red, female flowers predominantly yellow or green.

Painted in 1977 from a specimen at the Rio Demini, a tributary of the Rio Negro in the Amazonas region of Brazil.

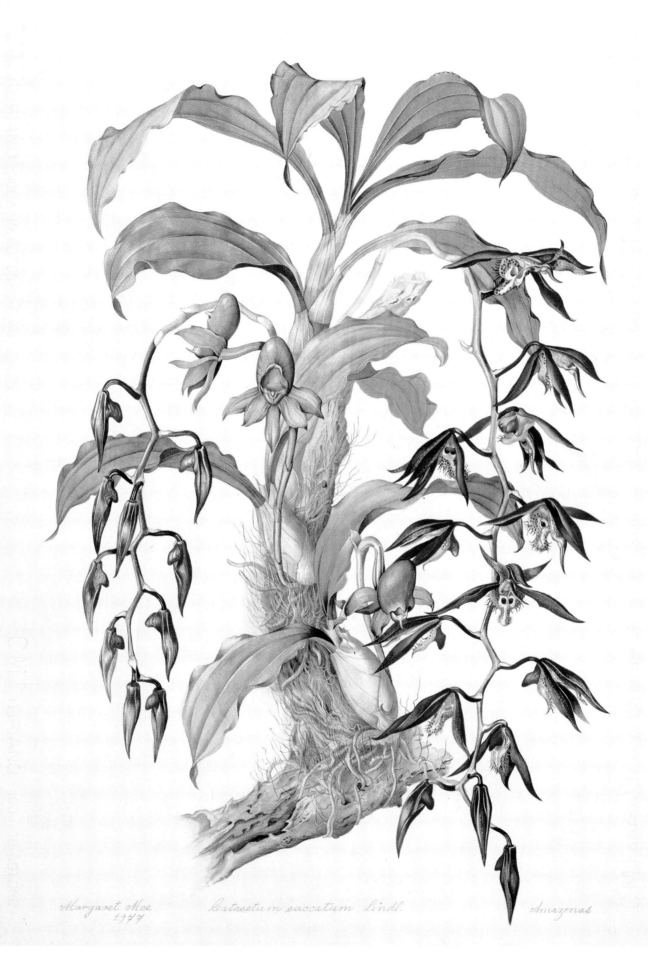

Margaret Mee
1977

Catasetum saccatum Lindl.

Amazonas

PLATE 38

Gustavia pulchra Miers Lecythidaceae

ARTIST: MARGARET MEE

The genus *Gustavia*, which now includes at least forty-one species, all of them tropical American trees, was founded on *G. augusta* by Carl Linnaeus in 1775. He dedicated it to Gustavus III (1746–92) who was King of Sweden 1771–92 and who sent him barrels of Surinam plants in spirit. Tragically Gustavus's aim of giving all Swedes equal privileges led to his assassination by a disgruntled noble. *Gustavia augusta* has a wide distribution, occurring in Surinam, French Guiana, Venezuela, Brazil, and Peru. *Gustavia pulchra*, figured here, was discovered by the intrepid English botanical collector Richard Spruce in December 1851 on the Orinoco river in western Brazil; it also occurs on the upper and middle Rio Negro and is recorded as being a common tree to 18 m (60 feet) high in periodically flooded valley bottoms. The flowers are about 12.5 cm (5 in.) across.

Painted in 1979 from a specimen from the area of the upper Rio Negro and Brazil/Venezuela border.

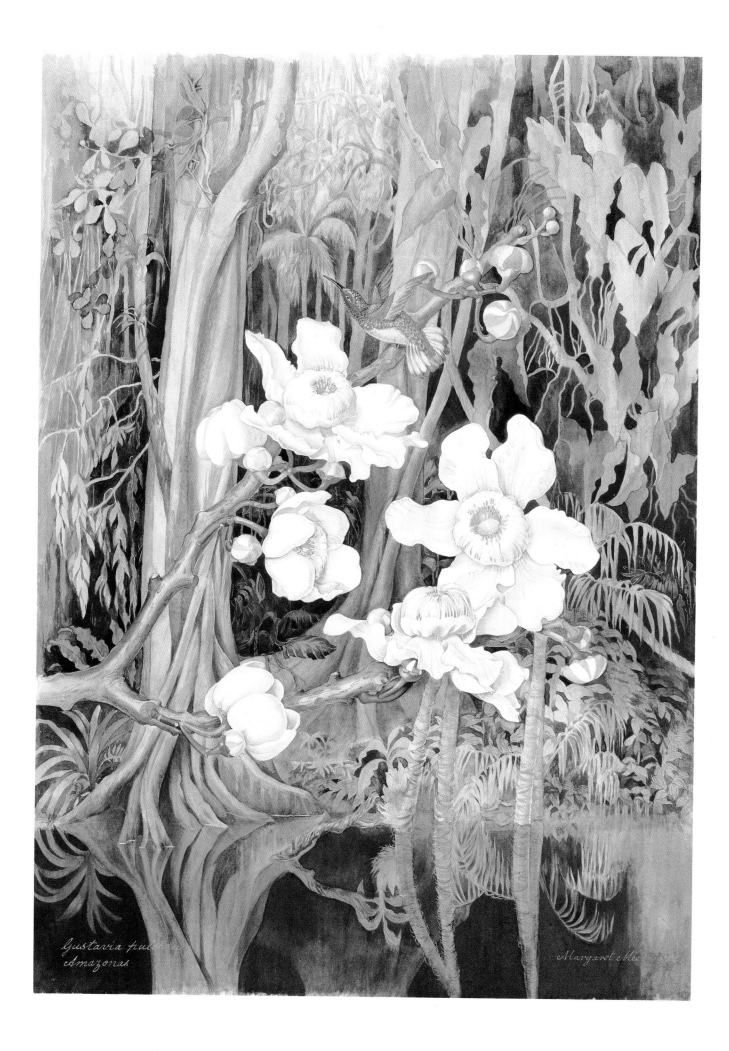

Gustavia pulchra
Amazonas

Margaret Mee

PLATE 39

Buddleja brasiliensis Jacquin fil.
and *B. tubiflora* Bentham Loganiaceae

ARTIST: VALERIE PRICE

The Buddleja most familiar to gardeners in the British Isles is the Butterfly Bush, *B. davidii* Franchet (syn. *B. variabilis* Hemsley) from western and central China, which entices nectar-seeking butterflies to its massed scented flowers, produces fruits with wind-borne seed in great quantity, colonizes waste places and even establishes itself on walls and derelict buildings. The genus comprises, however, about 100 other species, of which eleven with lilac, lavender, purple or white flowers from eastern Asia are hardy in England. It extends into Madagascar, the West Indies and South America, whence have come a few species with orange flowers, all but one, *B. globosa* Hope, needing glasshouse protection in British gardens.

The generic name commemorates the Reverend Adam Buddle (*c.* 1660–1715), a noted amateur botanist especially expert in mosses, who amassed a large herbarium now in the British Museum (Natural History), London.

LEFT *B. brasiliensis* makes a bush up to about 3.5 m ($11\frac{1}{2}$ ft high) with coarse foliage, the paired leaves basally clasping the stem, and numerous clusters of small orange flowers less than 1 cm ($\frac{2}{5}$ in.) long terminating the shoots. The name *B. brasiliensis* (1824) has priority of publication over *B. australis* (1829). Described from Brazil, it is recorded also from Bolivia, Paraguay and Argentina.

RIGHT *B. tubiflora* has similar growth but larger orange flowers about 1.5 cm ($\frac{3}{5}$ in.) long. It grows in Brazil and Paraguay.

Painted from a specimen at the Royal Botanic Gardens, Kew for The Plantsman.

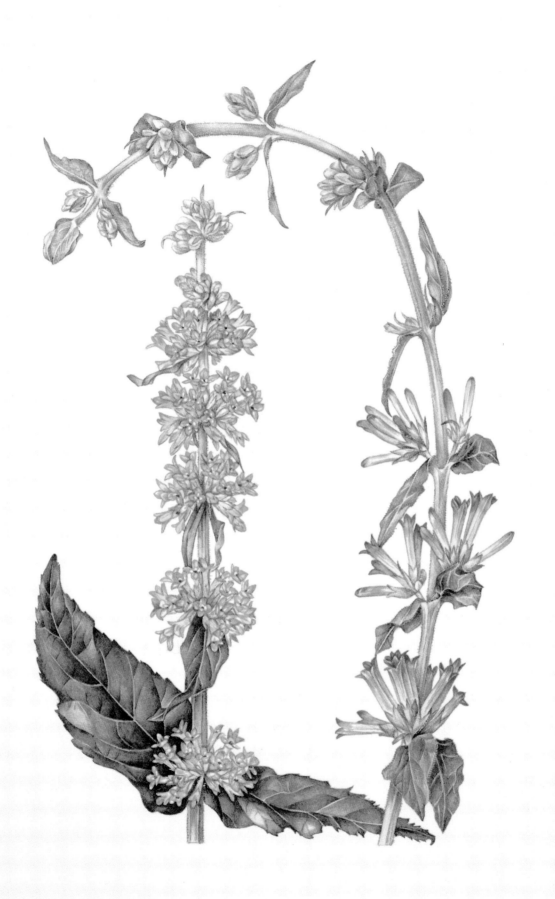

PLATE 40

Ophrys species Orchidaceae

ARTIST: VALERIE PRICE

The generic name *Ophrys* (from Greek *ophrus*, 'brow, eyebrow') was used by Pliny (1st cent. AD) for a two-leaved plant seemingly in no way connected with the orchidaceous genus now so named. This comprises about thirty species in Europe, Asia Minor and North Africa. Most of them inhabit the Mediterranean region, but four species occur in Britain. They have paired rounded underground tubers and small flowers sometimes mimicking insects. The lip of the flower produces a scent in some species so highly attractive to female-seeking male bees or wasps that they try to copulate with the flower and thereby get pollen-masses (pollinia) attached to their heads; copulating afterwards with another flower they transfer this pollen to it. Such a method of cross-pollination depends for success on the chance of the right bee or wasp being sex-hungry at the right time for the flower; *O. apifera* is mostly self-pollinated.

The Bee Orchid (*Ophrys apifera* Hudson), on the left, is widespread in England and Wales but very local and varying greatly from year to year in the number of flowering individuals. It has a reddish-brown softly hairy rounded lip, two narrow yellowish sepals and three broad pink sepals.

The Fly Orchid (*Ophrys insectifera* Linnaeus, syn. *O. muscifera* Hudson), in the centre, is widely distributed in England and occurs also in Wales and Ireland. The lip is brown with a blue band and two-lobed at the base, the sepals are greenish.

The Early Spider Orchid (*Ophrys sphegodes* Miller, syn. *O. arachnites* (Linnaeus) Miller), on the right, is a species rare in southern England but widely distributed on the continent of Europe. It has a brown, rather rounded lip and greenish sepals.

Painted from specimens at the Royal Botanic Gardens, Kew as a competition entry.

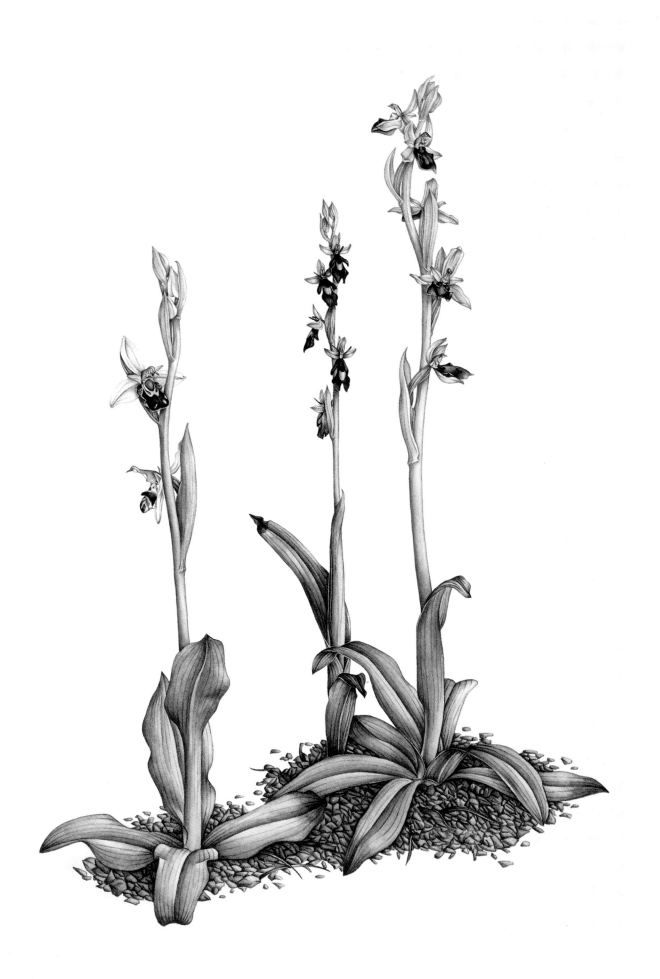

PLATE 41

Meconopsis × *sheldonii* G. Taylor Papaveraceae

ARTIST: RODELLA PURVES

With the exception of the western European *Meconopsis cambrica* (Linnaeus) Viguier, the Welsh Poppy, which is the type-species of the genus, all *Meconopsis* inhabit the Sino-Himalayan region, where they extend from Chitral and Kashmir to western and central China at altitudes above 2,000 m (6,000 feet). When George Taylor published his *Account of the Genus Meconopsis* (1934) he made evident the existence of spontaneously occurring garden hybrids but none had then established itself permanently. *Meconopsis* × *sheldonii* first arose in the garden of W. G. Sheldon at Oxted about 1934, its parents being *M. grandis* Prain and *M. betonicifolia* Franchet, the celebrated Blue Poppy introduced by F. Kingdon Ward under the name *M. baileyi* Prain. The parents are two closely allied species with purple or blue flowers. The same cross has been made several times. The hybrids are completely fertile and form a vigorous garden population, beautiful indeed but not more so than the parents.

L. G. Alexandre Viguier (1790–1867), a physician whose only botanical work is his Montpellier thesis *Histoire naturelle, médicinale et économique, des Pavots et des Argémones* (1814), coined the name *Meconopsis* from Greek *mēkōn*, 'poppy', *ŏpsis*, 'aspect, resemblance'.

Painted as a private commission in June 1987.

120

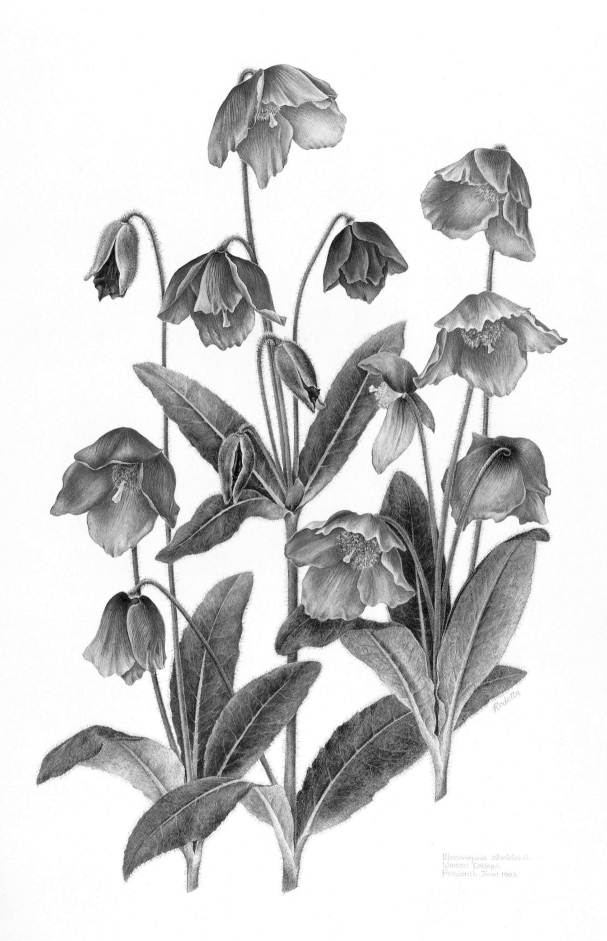

Meconopsis sheldonii.
Winton Cottage,
Penicuik June 1987.

Redutta

PLATE 42

Strelitzia reginae Aiton Strelitziaceae or Musaceae

ARTIST: RODELLA PURVES

Strelitzia is a genus with five species in South Africa and is remarkably distinct from all other genera. Its members are robust plants up to 10 m (30 feet) high, though mostly under 5 m (15 feet), with large leaves in two rows resembling those of the bananas (*Musa*). In northern Europe they are suitable only for large warm glasshouses but are widely cultivated in the open in tropical and subtropical countries for their bizarre flowers. The type-species, introduced into cultivation at Kew in 1773 from the Cape of Good Hope, was named *Strelitzia reginae* by Sir Joseph Banks in honour of Queen Charlotte (1744–1818), the wife of George III, who before her marriage in 1761 was a princess of the North German ducal family of Mecklenburg-Strelitz. Although Banks coined the name and his botanist-librarian Daniel Solander drew up the description, both were published as the work of the Kew gardener W. T. Aiton in 1789. The flowers are adapted to pollination by sunbirds, notably *Nectarina afra* (family Nectariniidae) which usually obtains nectar from them when perching on the long firm spathe; by pressing against the blue arrow-like projection (which sheathes five stamens and a style), the bird receives sticky pollen on its breast and later takes this to the receptive stigma of another flower. The colours red, orange and yellow are especially attractive to birds. The beak-like spathe with a crest of flowers has led to the name 'Crane Flower', their colours to 'Bird of Paradise Flower'.

Painted as a private commission in June 1988.

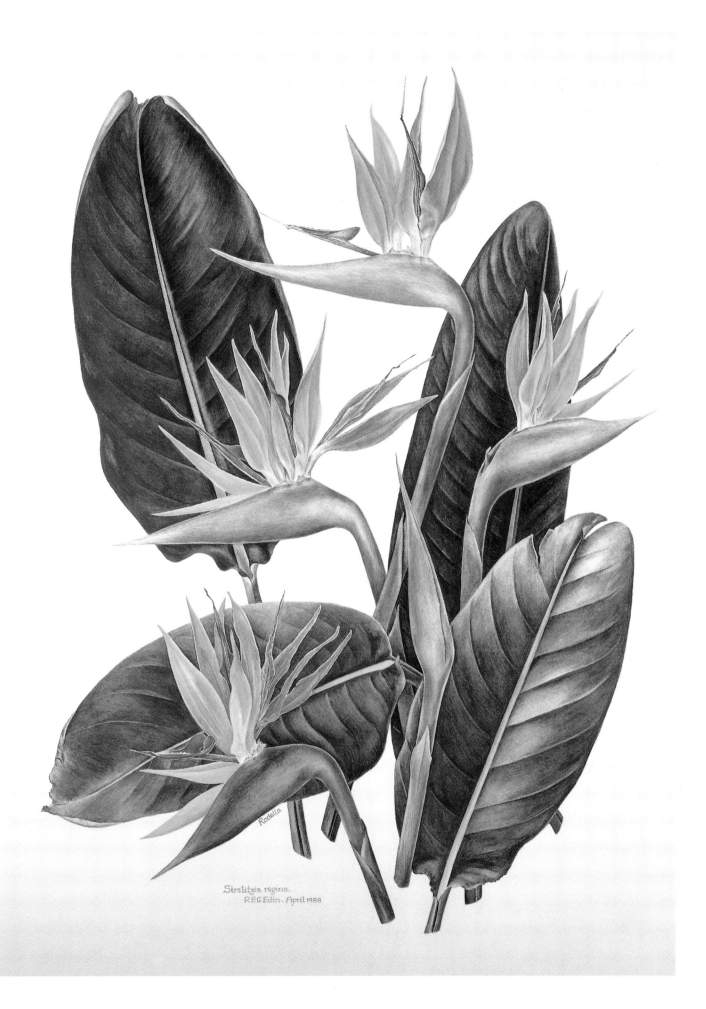

Strelitzia regina.
R.B.G.Edin. April 1988

Rodella

PLATE 43

Lilium monadelphum Bieberstein var. *szovitsianum*
(Fischer & Avé-Lallemant) Baker Liliaceae

ARTIST: RODELLA PURVES

A Caucasian lily inhabiting in nature thin mountain woodland and scrub
and the fringes of forest, up to 2,500 m (roughly 8,000 feet), this has proved
of easy cultivation in Britain. It bears up to twenty powerfully scented yellow
flowers on stems to 3.5 m (5 feet) high with numerous leaves. Opinions vary
as to whether this plant with cinnabar pollen and the one with yellow or
orange pollen, also from the Caucasus and described in 1808 as *Lilium
monadelphum*, should be maintained as distinct species or as variants of the
same species. In typical *L. monadelphum* the stamens are often united at the
base 'into a single brotherhood' as implied by its name from *monos*, 'one',
adelphos, 'brother', whereas in *szovitsianum* they are always free. The first
introduction of the latter into cultivation is credited to Johann Nepomuk
Szovits (died 1830), a Hungarian apothecary at Odessa who in 1828 and
1829 sent many bulbs, seeds and specimens from the Caucasus and Armenia
to the Petrograd (now Leningrad) Botanic Garden.

Painted in July 1988 as a private commission, from this plant raised from seed.

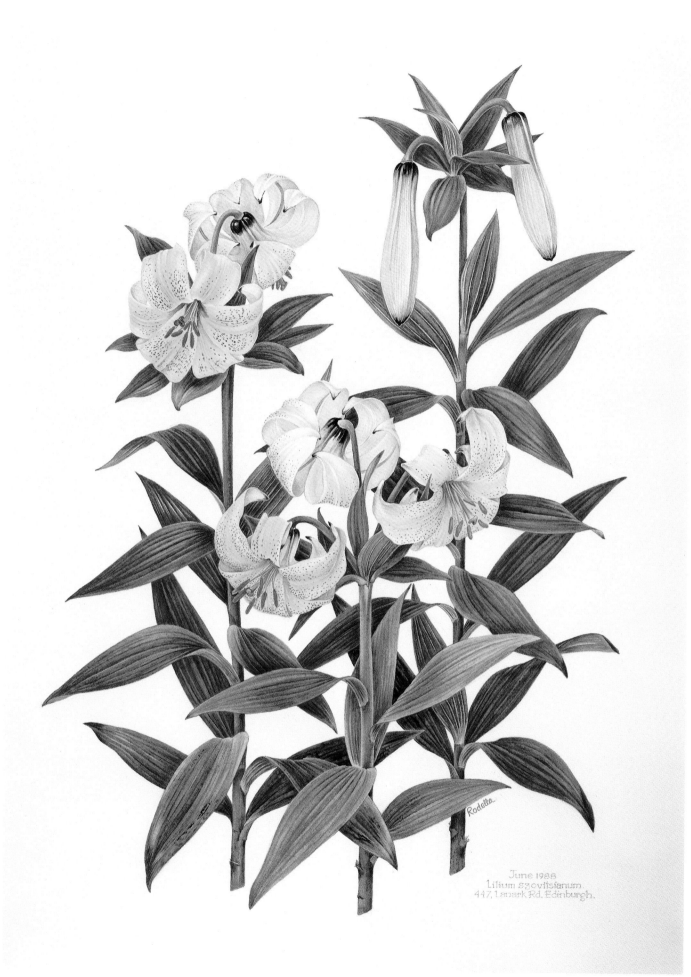

June 1988
Lilium szovitsianum
447 Lanark Rd. Edinburgh.

PLATE 44

Rhododendron macgregoriae F. Mueller Ericaceae

ARTIST: RODELLA PURVES

Tropical species unable to grow in the shade of forest trees can nevertheless survive within forested areas by becoming adapted to living on steep rocky slopes or cliffs or high upon trees, clinging to the bark and exploiting pockets of humus. Such tree-perching plants are termed *epiphytes*. Their intermittently moist and well-drained habitat, while giving them access to light, lacks nutriments readily available to ground-living plants. Nevertheless, as noted by C. G. G. J. van Steenis in his *The Mountain Flora of Java* (1972) 'dust from the air, detritus from fallen parts of plants, sometimes soil brought up by termites or ants, droppings from birds, etc. form the food source of the epiphytes which is also enriched by nitrogen coming down with rain during thunderstorms.' Epiphytes in the Malayan-New Guinea area include, besides many ferns, mosses and orchids, a surprising number of species of *Rhododendron*, some able to grow either on trees or among rocks whichever is available. Such a species is *Rhododendron macgregoriae*, widespread in New Guinea and either a shrub or small tree according to habitat. It possesses small leathery drought-resisting leaves, as do many epiphytes, and light to dark orange flowers about 2–3 cm ($\frac{3}{4}$–$1\frac{1}{4}$ in.) long.

The German-born Australian botanist Ferdinand von Mueller named this species in 1891 after Mary, the wife of Sir William Macgregor (1846–1919), from 1888 to 1898 Administrator (later Lieutenant Governor) of British New Guinea, after whom *Gentiana macgregorii* Hemsley and *Lycopodium macgregorii* Baker are named. Thus commemorating a MacGregor would have been unthinkable from 1693 to 1775 when the clan, notorious in the Scottish Highlands for cattle-thieving, was outlawed and persecuted and the use of the name MacGregor banned.

Painted in June 1988 as a private commission from a specimen introduced into the Royal Botanic Garden, Edinburgh from Papua, New Guinea.

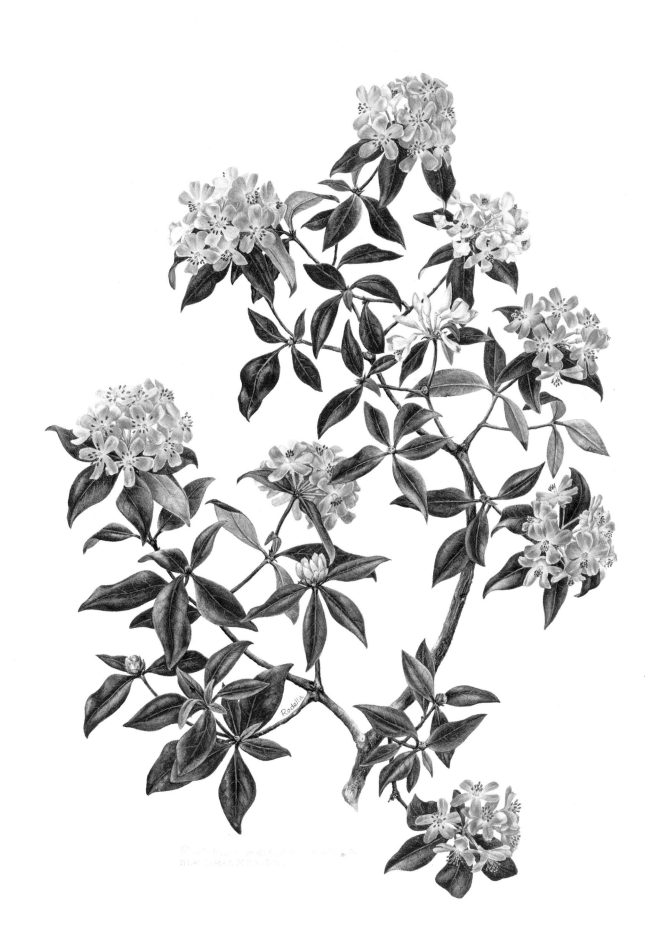

PLATE 45

Tropical Glasshouse Plants

ARTIST: PANDORA SELLARS

Within the Princess of Wales Conservatory at the Royal Botanic Gardens, Kew there grows an extraordinary assortment of plants illustrative in particular of the floristic diversity of the moist tropics. A few of these are depicted here.

TOP LEFT *Nymphaea micrantha* or allied species, one of a series of blue waterlilies ranging from Egypt, the type region for *Nymphaea caerulea* Savigny, over tropical Africa to South Africa, the type region for *N. capensis* Thunberg. Family Nymphaeaceae.

LOWER CENTRE *Polystachya melliodora* Cribb, a terrestrial orchid with honey-scented pink flowers of long-lasting waxy texture which grows at 1,500 m (5,000 feet) in the Mufindi district of Tanzania, whence it was introduced into cultivation at Kew in 1982. Family Orchidaceae.

TOP RIGHT *Cattleya forbesii* Lindley, a Brazilian species with flowers 8–10 cm (3–4 in.) across, the spreading sepals and petals greenish yellow, but the lip white or pale yellow outside but marked with orange or red inside. Family Orchidaceae.

The surrounding foliage includes *adiantum raddianum* (lower right), *begonia angusta* (centre front), and *asplenium bulbiferum* (lower left).

Painted in the artist's studio from plants in The Princess of Wales Conservatory, Kew as a gift from the Royal Botanic Gardens to HRH The Princess of Wales on the occasion of the official opening of the conservatory in July 1987.

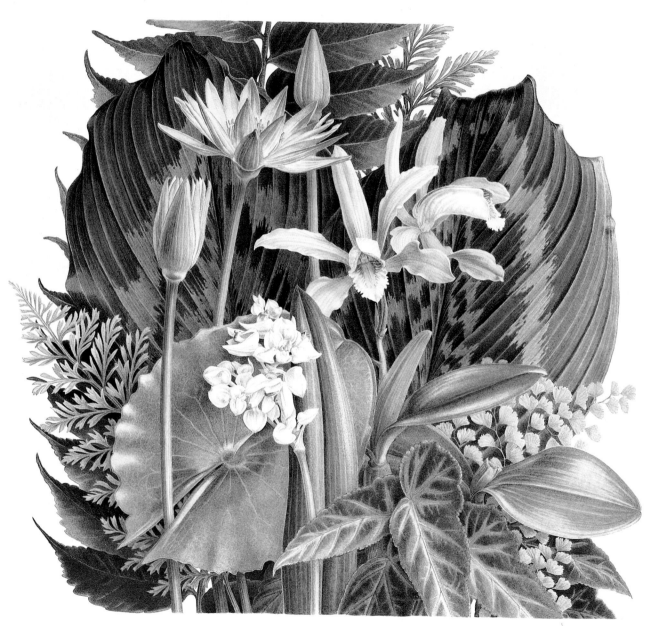

Brian Sellar '87

PLATE 46

Fritillaria species Liliaceae

ARTIST: PANDORA SELLARS

Species of the genus *Fritillaria* range from western Europe across northern Asia to western North America. They are bulbous plants allied to *Lilium*, with usually bell-shaped or tubular pendulous flowers having a nectar-producing pit or pouch near the base of each of the six segments. The plate depicts eight of the 100 or so species. From left to right these are:

1. *Fritillaria imperialis* Linnaeus var. *lutea*. Often known as the Crown Imperial (from the 16th-century name *Corona imperialis*), this species was introduced into European gardens from Turkey in several colour-forms during the late 16th century. In the wild it ranges from Asia Minor to Kashmir. The bulb has a strong foxy smell. At the base of the flower are six large rounded nectaries; the three-lobed style projects conspicuously from the bell-shaped flower.

2. *Fritillaria pallidiflora* Schrenk. This species with large pale yellow flowers has no terminal tuft of leaves as *F. imperialis* has and the style does not project from the flower. It is a native of eastern Siberia and northern China.

3. *Fritillaria verticillata* Willdenow. The small whitish flowers and upper leaves and bracts coiled at the end like tendrils distinguish this few-flowered species from those of eastern Siberia and northern China.

4–5. *Fritillaria meleagris* Linnaeus. The commonest European species, native or naturalized in northern Europe and extending westward to western Russia, has solitary purplish-tessellated or white flowers (see plate 4).

6. *Fritillaria acmopetala* Boissier. A Levantine species occurring in Turkey, Cyprus, Lebanon and Syria, this can be recognized by its large bell-shaped usually solitary flowers which are pale green suffused with reddish brown towards the base and have pointed outward curving tips.

7. *Fritillaria pyrenaica* Linnaeus. Rather like *F. acmopetala* but with dark heavily tessellated brownish or black flowers, this species is native to the Pyrenees and adjacent areas of southern France and northern Spain.

8. *Fritillaria persica* Linnaeus. Introduced into European gardens in the 16th century from Turkey at the same time as *F. imperialis* and many other bulbous plants, this was described in 1601 as *Lilium susianum* indicating its origin in Iran although it also occurs in southern Turkey, Jordan and Israel. The numerous dark flowers may be in shades of purple, black, grey or green.

Painted in 1989 for an exhibition at Kew Gardens Gallery.

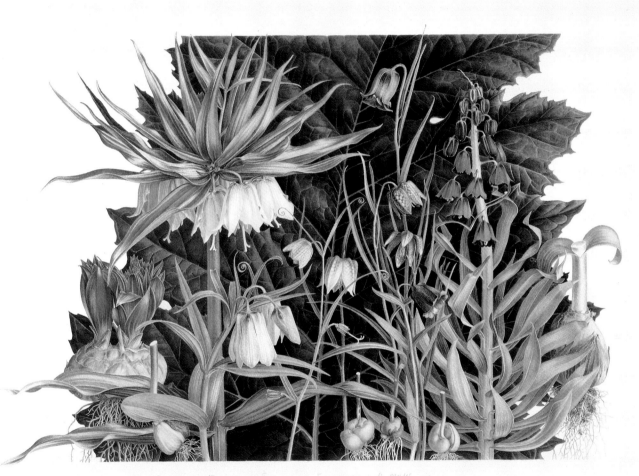

F. imperialis, F. imperialis, F. meleagris, F. meleagris, F. acmopetala, F. pyrenaica + A. mollis

PLATE 47

Tropical Glasshouse Plants

ARTIST: PANDORA SELLARS

This flowerpiece illustrates some tropical plants cultivated in a warm glass-house.

TOP *Philodendron* species. The five-lobed leaves are from a plant cultivated as *P. panduriforme* but probably *P. bipennifolium* Schott. Philodendrons are stout climbing plants usually with large leaves, which may vary in shape and size according to the plant's maturity, and as there are possibly 500 species, all tropical American, their identification is extremely difficult. Family Araceae.

CENTRE AND BELOW *Calathea roseopicta* (Linden) Regel. Has broadly elliptic leaves with silvery markings and a red midrib on the upper surface and a red lower surface. It is a native of Brazil. The genus includes possibly 300 species, all tropical American, a few of which produce edible tubers. Family Marantaceae.

CENTRE AND BELOW RIGHT *Paphiopedilum spicerianum* (Reichenbach fil.) Pfitzer. A slipper orchid from Assam, notable for the large arching white upper sepal and the two downward curved yellowish green petals with wavy margins. An orchid-collector for the firm of Sander of St Albans, having learned by deceit of its habitat in Assam, in 1884 sent 40,000 plants to England where Sander sold them at auction. By such large-scale devastating and unscrupulous collecting many orchids have been brought near to extinction or even exterminated. *P. spicerianum* is a parent of many hybrids. Family Orchidaceae.

Painted for The British Museum (Natural History) from plants in the greenhouse of the artist's husband.

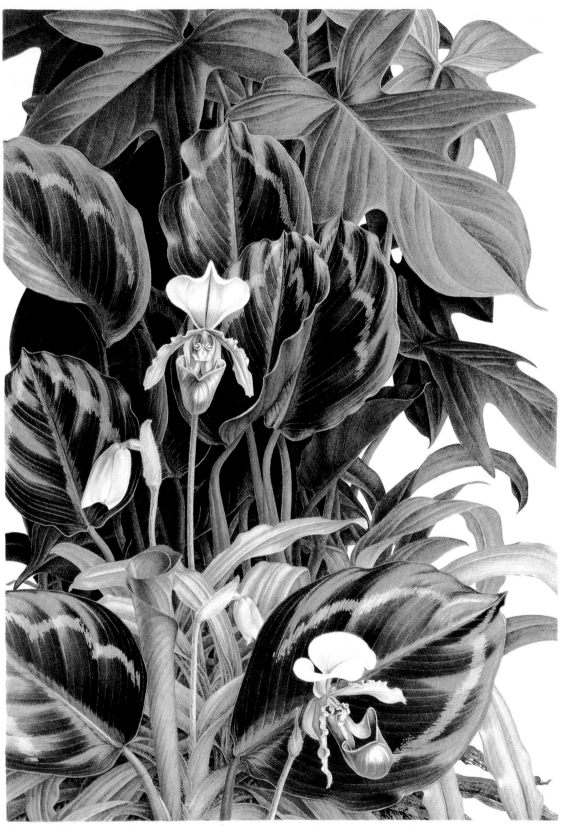

Paphopedilum spicerianum, Calathea rosea-picta,
Philodendron pandura forme.

Pandora Sellars '85

PLATE 48

Stuartia (or *Stewartia*) *malachodendron* Linnaeus Theaceae

ARTIST: MARGARET STONES

In 1746 Carl Linnaeus described and illustrated a new genus from eastern North America which he named *Stewartia* in honour of John Stuart, 3rd Earl of Bute (1713–92) because the drawing he had received from England incorrectly called him 'Stewart'. John Mitchell (1711–68), a Virginia-born physician, sent from Virginia for publication in Europe an account of new and little-known genera of American plants, one being the same as Linnaeus' *Stewartia* which he had named *Malachodendron*; this was published at Nürnberg in 1748 and again in 1769. Linnaeus named the only species then known *Stewartia malachodendron* in 1753, but L'Héritier in 1785 amended *Stewartia* to *Stuartia*. Since then there has been controversy over which name should be adopted for this genus with six species in eastern North America and eastern Asia.

The origin of this nomenclatural uncertainty goes back to the 12th century when King David I of Scotland appointed a Norman noble Walter Fitzallan as hereditary Steward of Scotland. A descendant, Robert the Stewart or Steward, became King of Scotland; he had nine illegitimate children, all legitimized by the Pope, as well as other illegitimate children, from whom the Stewart families of Scotland are descended. Apparently the education in France of Mary, Queen of Scots (1542–87), led her to prefer a French spelling 'Stuart' which some other Stewart families adopted, among them the Earls of Bute. As Linnaeus's *Stewartia* is an unintentional orthographic error, many authors have replaced it by *Stuartia*, which is orthographically correct.

Stuartia malachoendron makes a shrub or small tree to 6 m (20 feet) or more high, with beautiful wide-open flowers about 8–10 cm (3–4 in.) across, the five broad petals white, the filaments of the numerous stamens red-purple, the anthers blue. Its range extends from Florida westward to Louisiana, northward to Virginia.

Drawn in 1983 from material in the Arboretum at the Royal Botanic Gardens, Kew; exhibited at Beckett & Day, Bond Street, London in 1984.

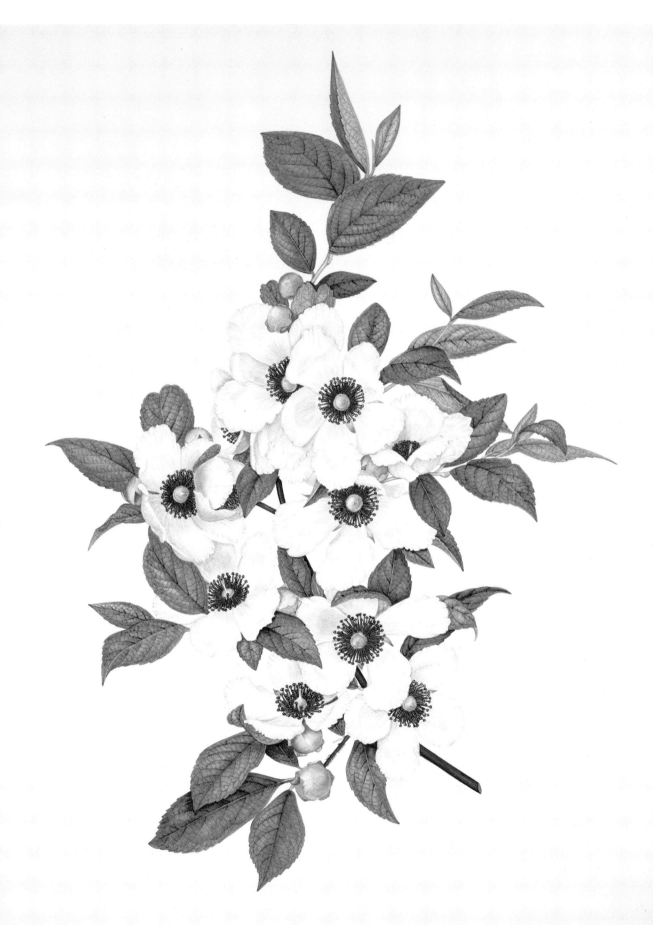

Stuartia malacodendron
Southern U.S.

Kew, June 24th 1983

PLATE 49

Orontium aquaticum Linnaeus　　　　　　　　　　　Araceae

ARTIST: MARGARET STONES

Whereas most members of the Arum family (Araceae) have a conspicuous, often white but also greenish-yellow to red spathe (see plate 55), in *Orontium aquaticum* the yellow inflorescence stands naked above a sheathing leaf which covers only the lower part of the stem. The inflorescence, which is 2–4 cm ($\frac{3}{4}$–$1\frac{1}{2}$ in. long), is a spike of closely packed yellow flowers, whence the vernacular name 'Golden Club', below which is a white waxy-looking area of stem, becoming pink lower down. It grows in shallow water and on the edges of lakes and ponds in eastern North America from Massachusetts and New York state south to Florida and Louisiana. When in flower it gives the impression of lighted candles arising out of the water. The application of the Greek name *orontion* is obscure; Linnaeus, however, was quite content to transfer an Ancient Greek or Latin name, such as *cactus*, *ceanothus*, *orontium* and *ptelea*, to an exclusively American genus unknown in ancient times.

Drawn from a specimen collected in Louisiana, USA, in 1984 for the artist's 'Louisiana Flora' project.

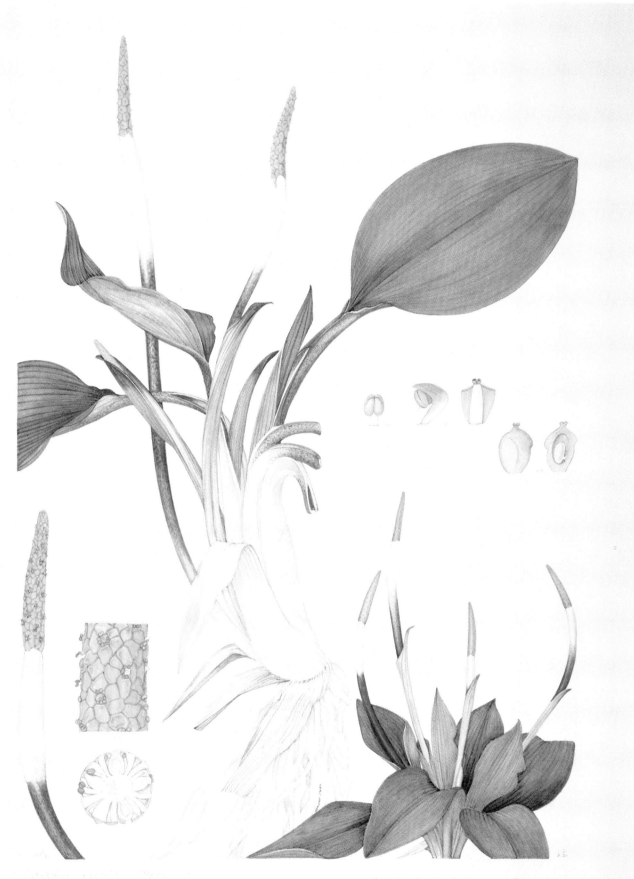

PLATE 50

Iris susiana Linnaeus forma *westii* (Dinsmore) Sealy Iridaceae

ARTIST: MARGARET STONES

In Lebanon and adjoining regions grow a number of irises characterized by having seeds with a large thick circular white appendage (aril), whence the sectional name *Oncocyclus* from Greek *ŏnkŏs*, 'swelling', *kuklŏs* 'circle'. Of these the first to become known was named *Iris susiana*, a name it retains, by Clusius in 1583, it having been sent to Vienna from Constantinople at the end of 1573 by the Imperial ambassador Ogier Busbecq. It attracted attention by its very large sombre flowers, densely covered with purple-black veins and spots on a greyish background. A number of plants closely resembling *Iris susiana* in everything but colour occur in Lebanon; although given individual specific names they are probably best considered variants of one species for which the earliest name is *I. susiana* adopted by Linnaeus in 1753. The one from Lebanon named *I. westii* by Dinsmore has the standards (the three erect parts of the flower) pale lilac with darker blue-lilac (instead of purple-black) veins and spots and the falls (the three descending parts of the flower) densely veined with purple on a yellowish background and with a large deep brown patch at the base. The classification and naming of the *Oncocyclus* irises is difficult and controversial but they are very beautiful plants, regrettably difficult to grow in gardens and unfortunately in danger of extinction in the wild.

Painted for Curtis's Botanical Magazine N.S.t. 550 (1969).

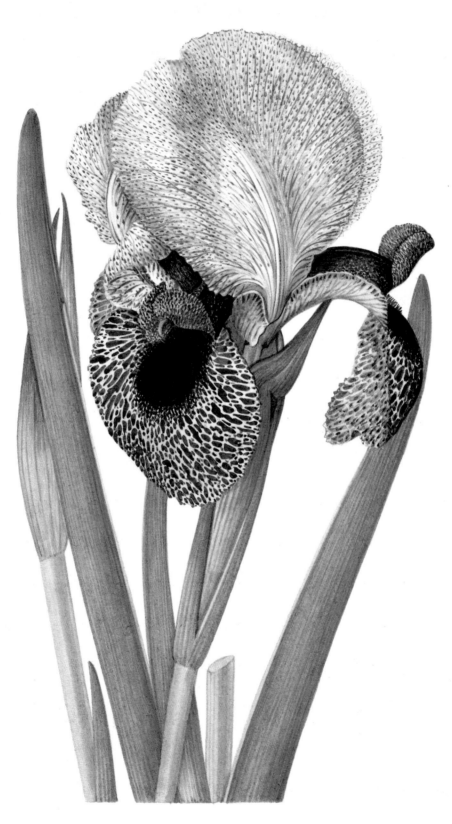

Margaret Stones
14.5.1968

PLATE 51

Brownea × *crawfordii* W. Watson Leguminosae (Caesalpiniaceae)

ARTIST: WENDY WALSH

Brownea is a tropical American genus of about thirty species of shrubs or trees with showy flowers, often in dense many-flowered clusters. In temperate countries they need glasshouse cultivation. The flowers produce abundant nectar and, as the 10 to 15 stamens, together with the style, project above the corolla, they are adapted to pollination by humming-birds. The plant illustrated is a garden hybrid between two Central American species, *B. grandiceps* and *B. macrophylla*, raised by an Irish horticulturist William H. Crawford (d. 1858). In general habit, leaf and flower it resembles *B. macrophylla* more than *B. grandiceps* but the large flower-heads terminate shoots as in the latter. It grows to about 5 m (15 feet) with leaves to 60 cm (2 feet) long consisting of 10 to 16 pairs of large leaflets without, however, a terminal leaflet. The generic name commemorates an Irish physician, Patrick Browne (*c.* 1720–90) of County Mayo, who lived from 1746 to 1755 in Jamaica and published an important *Civil and Natural History of Jamaica* (1756: 2nd edn 1789) illustrated by G. D. Ehret.

Painted from a specimen grown at the Royal Botanic Gardens, Kew in 1984; published in An Irish Florilegium II (*1988*).

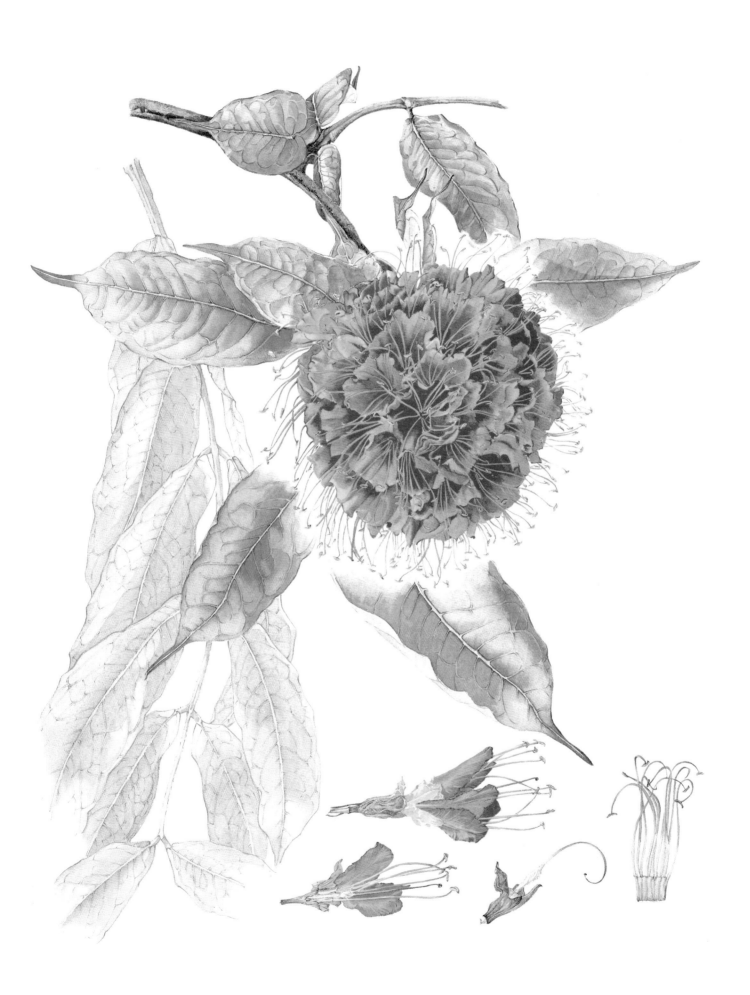

PLATE 52

Dryas octopetala Linnaeus Rosaceae

ARTIST: WENDY WALSH

The Mountain Avens, *Dryas octopetala*, is essentially an Arctic-Alpine species ascending in the Alps to 2,500 m (8,200 feet) but found in Ireland down to sea-level. A creeping plant with spreading woody stems which can form wide mats several metres across, it is one of the most conspicuous ornaments of the Burren region when covered with its white flowers, like small single roses, about 4 cm ($1\frac{3}{4}$ in.) broad. They have usually but not invariably eight petals. The leaves, dark green above but densely covered below with white hairs, have small rounded marginal teeth and their somewhat oak-like appearance caused Linnaeus to give it the name *Dryas* (from Greek *druas* 'tree nymph', *drus* 'oak') in his *Genera Plantarum* (1737) and *Flora Lapponica* (1737). He came across it on 16 July 1732 in Swedish Lapland, where it is not uncommon, but Clusius had already excellently described and illustrated it, as *Chamaedrys alpina cistiflore*, from the Austrian Alps in 1583 (see p. 15) The flowers are followed by fruiting heads with long feathery or woolly styles giving them much the same appearance as the fruiting heads of Traveller's Joy (*Clematis vitalba*). Ultimately the winds disperse them.

The unmistakable leaves of this species found in post-glacial deposits indicate its widespread occurrence in places where it no longer grows, e.g. near Cambridge (Barnwell) and in the Lea Valley, about 28,000 years ago.

Painted from a specimen collected in County Clare, Eire, in 1981; published in An Irish Florilegium *(1983)*.

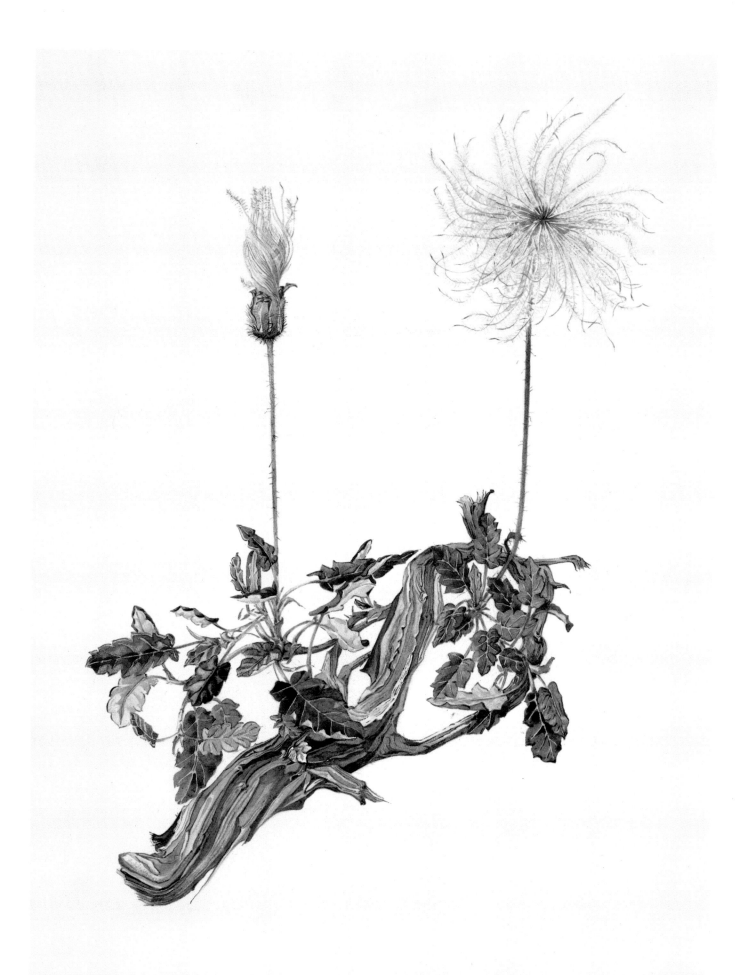

PLATE 53

Scilla verna Hudson Liliaceae (Hyacinthaceae)

Artist: Wendy Walsh

When in flower only 5–20 cm (2–8 in.) high, with 3 to 6 very narrow leaves, the Vernal Squill cannot compete with luxuriant vegetation; accordingly it inhabits coastal rocky exposed places and the low turf characteristics of areas subject to strong winds and salt spray. In ecology it is thus a maritime species, in geographical distribution an Atlantic species. Its range extends from the Faeroes and Norway to the northern and western Isles and coast of Scotland, eastern Ireland, the Isle of Man, Wales, Cornwall and Devon, then along western France to Spain and Portugal. The first record of *Scilla verna* in the British Isles dates from 1650, a Mr Heaton having found it near Dublin. Although very local, it may be abundant in some places. It flowers in April and May. The small whitish ovoid bulb is about 1.5–3 cm ($\frac{1}{2}$–$1\frac{1}{4}$ in.) long. The bracts are about as long as or longer than the flower-stalks, the lower of which are much longer than the upper ones, thus bringing the 2 to 12 starry blue flowers to almost the same level. The Latin name *scilla*, Greek *skilla*, is the ancient name for the medicinal squill, the widespread Mediterranean plant with a huge bulb and a long inflorescence of white flowers, known as *Urginea maritima* (Linnaeus) Baker or *Drimia maritima* (Linnaeus) Stearn.

Painted from a specimen collected in County Louth, Eire, in 1984; published in An Irish Florilegium II (*1988*).

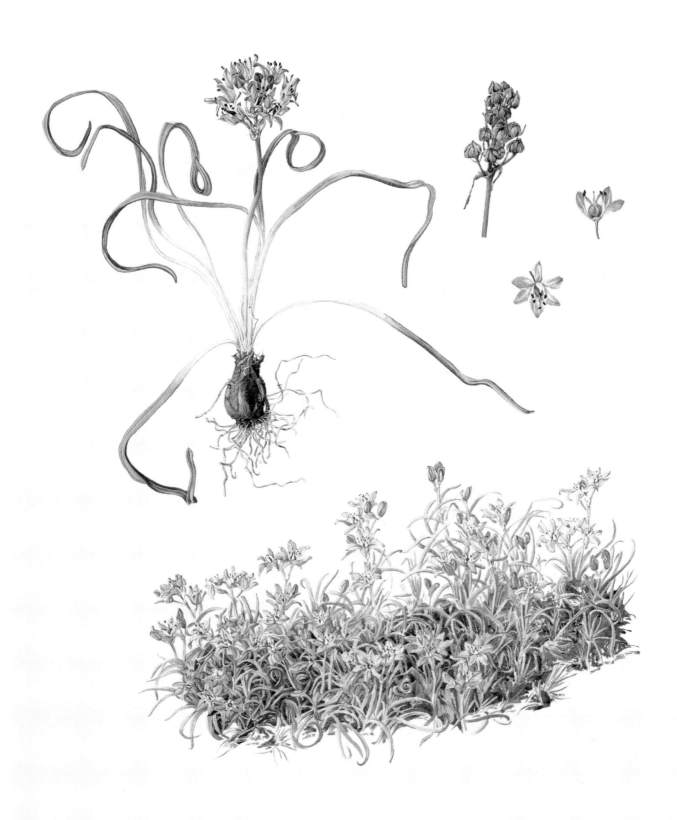

PLATE 54

Nuphar lutea (Linnaeus) Smith Nymphaeaceae

ARTIST: ANN WEBSTER

The Yellow Waterlily, sometimes called Brandy Bottle, grows in large ponds, lakes and unpolluted slow-flowing rivers over most of the British Isles except the north of Scotland and has a wide distribution on the continent of Europe and northern Asia. From an extensively creeping rhizome rooted in mud and sediment it produces both large, somewhat leathery floating leaves up to 40 cm ($1\frac{1}{2}$ feet) long and nearly as broad, and very thin submerged leaves. Out of the massed leaves and held high above them arise the bowl-shaped yellow flowers about 5 cm (2 in.) across with a somewhat unpleasant alcoholic smell. James Edward Smith described them in 1825 as having 'the scent of brandy or ratafia, whence they are called Brandy-bottles in Norfolk,' his native county. 'More exact,' commented Geoffrey Grigson in 1955, 'would be the smell of the stale dregs of a sweet white wine.' The name 'Brandy Bottle' is used in several other counties besides Norfolk. A very local English name 'Platterdock' taken, like 'Cat-tail' (*Typha*) and 'Huckleberry' (*Vaccinium*), to eastern North America by early colonists, has become the name 'Spatterdock' widely used there for native yellow waterlilies.

Linnaeus in 1753 included both the white and yellow waterlilies in the same genus (*Nymphaea*, typified by *N. alba* Linnaeus). Separating generically the yellow waterlilies from the white, Smith asked advice in November 1808 from his learned friend the classical scholar Samuel Goodenough, Bishop of Carlisle, about a suitable generic name. The Bishop suggested *Nuphar*, used by Dioscorides (Book 3 no. 149), stating 'I should prefer *Nuphar*, and should suppose it a feminine name, and make the species ranged under it, *lutea*, &c.' Accordingly Smith deliberately published the name *Nuphar lutea* in 1809, despite which many later authors have called it *Nuphar luteum* by analogy with *huphear* 'mistletoe' which is of neuter gender.

Painted in 1955/6 for the Kew Series British Wild Flowers, *1958.*

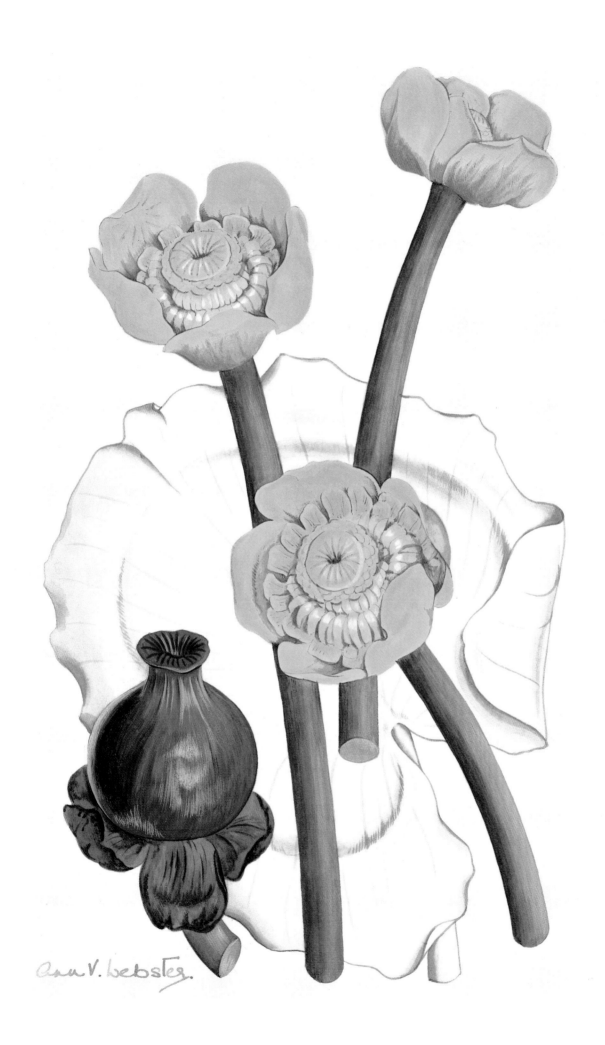

Ann V. Webster.

PLATE 55

Arum maculatum Linnaeus Araceae

ARTIST: ANN WEBSTER

Variously known as Lords and Ladies, Adam and Eve, Cuckoo-pint, Wake-robin, Priest's Pintle and similar sexually significant names, and also as Jack-in-the-pulpit and Parson-in-the-pulpit, *Arum maculatum* L. is a common and widespread shade-tolerant plant often growing in hedgerows in England, southern Scotland and Ireland and extending on the Continent south to Portugal, Spain, Italy and Greece and eastward to the Ukraine and northern Turkey. The erect penis-suggestive purplish or yellow spadix arising out of a pale green, often purple-flecked swollen spathe makes it unlike any other North European plant in appearance and has suggested some of its rude vernacular names referring to priests. To Thomas Hardy it appeared 'like an apoplectic saint in a niche of malachite'. The fertile part of the inflorescence hides within the lower part of the spathe, with a zone of crowded female flowers in the lower part of the inflorescence, then a sterile zone surmounted by a zone of crowded male flowers, above which zone, outside the spathe, stands the spadix. This organ becomes warm and gives out a smell attractive to midges; they crawl downward into the enclosed part of the spathe containing the flowers. In autumn the fruiting spikes with bright red berries become attractive to birds.

For a time the tubers were used to make starch, particularly on the island of Portland, but the fine crystals of calcium oxalate associated with it blistered the hands of servants.

Painted in 1955/6 for the Kew Series British Wild Flowers, *1958.*

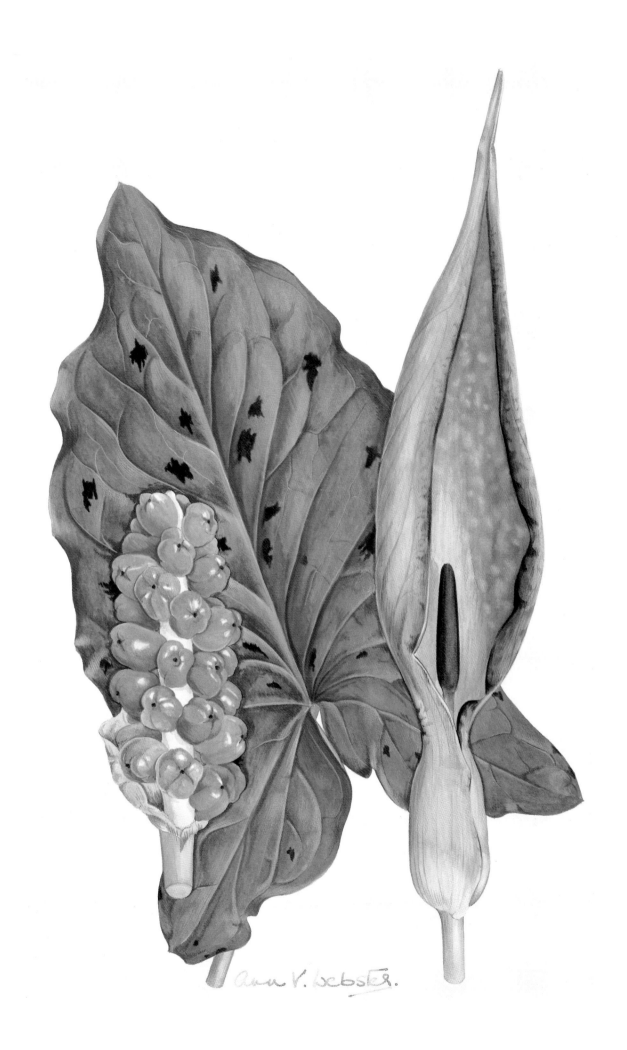

Ann V. Webster.

PLATE 56

Lamium galeobdolon (Linnaeus) Linnaeus Labiatae (Lamiaceae)

ARTIST: ANN WEBSTER

Yellow Archangel or Yellow Deadnettle is a species recognizable by its nettle-like but stingless leaves and its whorls of yellow flowers with the upper curved hood-like lip a paler yellow than the sharply three-lobed orange and brown spotted lower lip. It was placed by Linnaeus in the genus *Lamium* together with the Common White Deadnettle, *Lamium album* Linnaeus, and the Spotted Deadnettle, *Lamium maculatum* Linnaeus, and then transferred to a separate genus as *Galeobdolon luteum* Hudson and *Lamiastum galeobdolon* (Linnaeus) Ehrendorfer & Polatschek. However, in the latest comprehensive revision (1989) of these plants, J. Mennema has restored it to *Lamium*. Within the species three subspecies are distinguished: *galeobdolon* with long invasive runners, widespread from Scandinavia to central and eastern Europe and the Balkan Peninsula, but with only a limited area in eastern England; *montanum* (Persoon) Hayek, likewise with long runners, widespread in western Europe including England and Wales but only the south of Scotland; *flavidum* (F. Hermann) Löve & Löve, without runners and with smaller flowers, in southern Europe. By some botanists these are regarded as different species. The commonest one in gardens is a very invasive variegated form of subsp. *galeobdolon*, the leaves of which have on the upper surface a central green patch bounded on both sides by an irregular silvery band, this encircled by a narrow green leaf margin. This has been named forma *argentatum* (Smejkal) Mennema. It is a good rapid-growing ground-cover plant.

Painted in 1955/6 for the Kew Series British Wild Flowers, *1958.*

Ann V. Webster.

The artists

BATES, Mary (b. 1945) Mary Bates expanded her lifelong interest in botanical illustration when her children went to school, and has subsequently made numerous illustrations of plants growing in the Royal Botanic Garden, Edinburgh. She has contributed to *Flora of Bhutan* by Grierson & Long, vol. 1 parts 2 and 3, and *A revision of Dendrobium section Oxyglossum* by Reeve & Woods (in press), as well as drawings and paintings for *The Plantsman*, *The Kew Magazine* and for papers in *Notes from the Royal Botanic Garden, Edinburgh*. She has also undertaken various private commissions.

BLAMEY, Marjorie (b. 1918) Born in Ceylon, the daughter of a doctor, Marjorie Blamey had a varied career as a photographer, actress, then dairy farmer, before concentrating her talents from 1968 onwards upon the illustration of many books on plants. Her major achievement is over 2,400 illustrations in colour for *The Illustrated Flora of Britain and Northern Europe* (1989) with text by Christopher Grey-Wilson. She has been awarded two Gold Medals by the Royal Horticultural Society and a Gold Certificate by The Alpine Garden Society, and is at present working on a collection to be exhibited at Kew in the autumn of 1990.

COOMBS, Jill (b. 1935) Jill Coombs studied ceramics, illustration and typography at West Sussex College of Art and worked for several years from 1978 as a freelance artist for the Royal Botanic Gardens, Kew on Floras of Iraq, Qatar and Egypt. She was awarded Gold Medals for Botanical Paintings by the Royal Horticultural Society in 1978, 1985 and 1988. In 1986 she was invited to hold a one woman show at the Arun Art Centre in Sussex. She has illustrated *Plant Portraits* by Beth Chatto (1985) and *Herbs for Cooking and Health* by Christine Grey-Wilson (1987) and has contributed to several other botanical publications including *The Kew Magazine*.

EVERARD, Barbara (b. 1910) Barbara Everard began drawing and painting flowers in 1947 when in the Far East. She has provided illustrations for many works, among them O. Polunin and A. Huxley, *Flowers of the Mediterranean* (1965), but her major work has been *Wild Flowers of the World* (1970) with text by Brian D. Morley. In 1976 she was awarded a Churchill Travelling Fellowship to paint endangered plants in Malaysia and was greatly helped in this venture by the Royal Botanic Gardens, Kew. She is head of the Barbara Everard Trust for Orchid Conservation.

FARRER, Ann (b. 1950) Ann Farrer, a relative of Reginald Farrer (1880–1920), grew up at Clapham, Yorkshire where Farrer lived when not travelling. After graduating from Manchester University in English and the History of Art she began

plant illustration in the Department of Botany at the British Museum (Natural History) in 1973 under the guidance of Dr. E. Launert. In 1977 she was awarded a Churchill Travelling Fellowship to draw plants for *Flowers of the Himalayas* by O. Polunin and J. D. A. Stainton (1984). This kindled a love of the Himalayas to which she returns frequently to lead trekking groups. She has provided illustrations for various floras at Kew and two handbooks for BSBI as well as numerous other projects. She has been awarded five Gold Medals by the Royal Horticultural Society and in 1988 was the first person to receive the Jill Smythies Award by the Linnean Society of London. She now works for *The Kew Magazine* and Kew monograph series as well as other publications and private commissions.

FOTHERGILL, Mark (b. 1959) Mark Fothergill's interest in the natural world was inherited from his father; his grandmother, who was a landscape painter, introduced him to the technique of watercolour painting. After studying Medieval History and Archeology at St Andrews University, he worked as an archeologist and during an expedition to the Andes of Peru he painted Andean plants in his spare time. On his return he took these paintings to the Royal Botanic Gardens, Kew. Encouraged by the staff at Kew he became a freelance illustrator there in 1986. He has contributed illustrations to *The Kew Magazine*, *The Plantsman*, *The European Garden Flora* and other publications, and has gained awards for work exhibited at the Royal Horticultural Society. He was expedition artist to the 1988 Kew Gardens expedition to the Pico das Almas mountains in Bahia, Brazil and followed this with four months' freelance botanical painting for various Brazilian collectors. He is now working at Kew on several projects including the Pico das Almas florula. He regards his talents as God-given and hopes that his work glorifies God.

GOAMAN, Victoria (b. 1951) The daughter of artists and the granddaughter of J. B. Priestley the novelist, Victoria Goaman began her career as a freelance botanical artist in the Department of Botany at the British Museum (Natural History) and has provided illustrations for various floras and twelve books, among them *Flowering Plants of the World* (1978) edited by V. H. Heywood, *Gardening on Walls* (1983) by C. Grey-Wilson and V. Matthews and *Garden Flowers* (1986) by C. Grey-Wilson.

GRIERSON, Mary (b. 1912) Mary Grierson, born of Scottish parents in Bangor, North Wales, worked during World War II for a photographic reconnaissance unit and studied cartographic drafting. Although she had painted flowers as a hobby, a course in botanical drawing by John Nash RA determined her future. In 1960 she was appointed botanical artist at the Royal Botanic Gardens, Kew, from which she retired in 1972, only to embark on a freelance career portraying native plants of Israel, Hawaii and Britain. She has contributed many plates to *Curtis's Botanical Magazine* and *Hooker's Icones Plantarum* and to Brian Mathew, *The Crocus* (1982) and has illustrated P. F. Hunt, *Orchidaceae* (1973), W. T. Stearn and C. Brickell, *An English Florilegium* (1987), C. Grey-Wilson, *The Genus Cyclamen* (1988) and B. Mathew, *Hellebores* (1989), among other publications. In 1986 she was awarded the Gold

Veitch Memorial Medal by the Royal Horticultural Society and received an honorary degree from the University of Reading in appreciation of her work as a botanical artist. She has also received four Gold Medals for Botanical Illustration from the RHS.

HAGUE, Josephine (b. 1928) Josephine Hague qualified in Textile Design at Liverpool College of Art, and had an examination piece selected by the Victoria & Albert Museum for their collection of contemporary textiles. After raising a family, she sought an art career in 1979 with a leading textile design studio in London. Preference for wider scope led to illustration for books, cards, calendars and botanical prints for a number of international publishers. Nine exhibitions of her work have included venues at the Royal Botanic Gardens, Kew, the Royal Horticultural Society, the Tryon Gallery, London, the Metropolitan Borough of Wirral Art Gallery, the Liverpool International Garden Festival and Liverpool University Botanic Gardens. Her awards for botanical drawing and painting include the Large International Gold Medal, and Royal Horticultural Society Gold Medals and Silver and Silver-gilt Lindley Medals for watercolour paintings and annotated exhibits of *Hedera* and *Sorbus*.

KING, Christabel (b. 1950) Having gained a degree in Botany from University College, London and worked for a year in a nursery garden, Christabel King studied scientific illustration at Middlesex Polytechnic for two years (1972–4) and then became a freelance artist. In 1975 she made her first painting for *Curtis's Botanical Magazine* and started as a part-time editor for the magazine. She has continued to contribute plates since it became *The Kew Magazine*, and her work has also appeared in other publications including *Flowering Plants of the World* edited by V. H. Heywood (1978), *Orchideenatlas* by H. Bechtel, P. Cribb and E. Launert (1979) and *All Good Things Around Us* by P. Michael (1980). She took part in 1987 in an expedition to Uganda to paint some of the unique flora of the Ruwenzori Mountains for *Africa's Mountains of the Moon* by Guy Yeoman (1989).

LANGHORNE, Joanna (b. 1945) After studying graphic design at the Central School of Art, London, Joanna Langhorne worked at the Freshwater Biological Association making zoological drawings for identification. She then became official artist at the Royal Botanic Gardens, Kew from 1973 to 1980, and now lives in Cumbria working as a freelance artist. Her work has been exhibited in many venues in Britain, the USA and Australia including the Royal Horticultural Society, the British Museum (Natural History) and the Chelsea Physic Garden. Commissions have included twelve designs for plates to commemorate the 250th anniversary of a Royal Garden at Kew and illustrations for *The Garden*, *The Kew Magazine* and *The Plantsman* from 1979 to the present. She is especially interested in botanical illustration for monographs.

LAVRIH, Cherry-Anne (b. 1946) Cherry-Anne Lavrih gained a Diploma in Art and Design at Brighton College of Art and won the David Murray Landscape

Painting Award from the Royal Academy in 1966. She became Head of the Art Department at Whyteleafe Grammar School for Girls, Surrey and later, after raising a family, taught at St Paul's Girls' Preparatory School in Hammersmith, London. In 1986 she left teaching to concentrate on her own work as a botanical artist, and went on to produce a number of studies for the Royal Botanic Gardens, Kew. In 1987 she was appointed as orchid artist to the Royal Horticultural Society her task being to paint for the Society's historical records the orchids to which the Society makes awards.

MEE, Margaret (1909–1988) Although distinguished as a botanical artist of the Amazon region, Brazil, Margaret Mee was born in England and trained at Camberwell School of Art. In 1952 she went out to Brazil with her husband, Greville Mee. The diversity and beauty of flowers in the Amazon rain forests entranced her and she devoted herself to collecting and portraying them, from 1956 to 1988 making many expeditions up the Amazon in a small boat, disdainful of the many hazards. Her paintings made in permanent gouache have been published in her three books, *Flowers of the Brazilian Forests* (1968), *Flores de Amazonas, Flowers of the Amazon* (1980), *In Search of the Flowers of the Amazon Forest* (1988), an illustrated autobiography, and in S. Mayo, *Margaret Mee's Amazon* (1989). Having survived all the dangers of her Amazonian explorations, she was killed on 30 November 1988 in a car accident near Leicester, England.

The species *Aechmea meeana* L. B. Smith (Bromeliaceae), *Catasetum meeae* Pabst (Orchidaceae), *Neoregelia margaretae* L. B. Smith (Bromeliaceae) and *Sobralia margaretae* Pabst (Orchidaceae), all named in her honour, are among the new Brazilian species she discovered.

PRICE, Valerie (b. 1958) Valerie Price was born in Sussex. She studied graphic design at Brighton and Middlesex Polytechnics, specializing in scientific illustration with a three-month placement at the Royal Botanic Gardens, Kew. In 1983 she started working as a freelance botanical illustrator, and has contributed to *The Kew Magazine*, *The Plantsman* and several other publications and books. She now lives in north London with her husband and young daughter.

PURVES, Rodella (b. 1945) Rodella Purves lives and works freelance in Edinburgh, where she was employed at the Royal Botanic Garden from 1969 to 1976. Her work has been exhibited by the Scottish Arts Council in 'The Plant' and 'Sowerby, Bauer, Hooker and Fitch', and in the International Exhibition of Botanical Art in Munich (1986). It is also in private collections, including those of various Government bodies and the Hunt Institute, USA. She exhibits regularly at Broughton Gallery by Biggar in Tweeddale. She has also contributed work to *Curtis's Botanical Magazine*, Elsevier International Publications and H. H. Davidian, *Rhododendron Species* vols 1 and 2, and she illustrates for *The Scotsman* newspaper and colour magazine and *The Kew Magazine*. She lectures regularly in Edinburgh on The Art of Botanical Illustration.

SELLARS, Pandora (b. 1936) Originally a textile designer, then a teacher, Pandora Sellars exhibited work at the Royal Horticultural Society and was introduced by Margaret Stones to *Curtis's Botanical Magazine* (now *The Kew Magazine*) for which she has worked intermittently ever since. Her publications include *Jersey Flora* (1984) and a Kew monograph *Genus Paphiopedilum* (1987), and among others to which she has contributed is *The Flowering of Kew* by Richard Mabey (1988). In 1987 she painted the design for the Franklin Mint commemorative plate for the Prince of Wales Conservatory at Kew and also the presentation painting for HRH The Princess of Wales.

STONES, Margaret (b. 1920) Margaret Stones was born in Victoria, Australia and studied at the Swinburne and National Gallery Schools in Melbourne. She trained as a nurse during World War II but was struck down by tuberculosis. During her long recovery in hospital she turned to painting flowers, and came to England in 1951. The quality of her work immediately impressed botanists at the British Museum (Natural History) and at Kew, where in 1958 she became principal contributing artist to *Curtis's Botanical Magazine*. She made 250 watercolours for Winifred Curtis's monumental *Endemic Flora of Tasmania* (1967–78). She has had numerous one woman shows, most notably a collection of Louisiana wild flowers at the Natural History Museum of the Smithsonian in Washington DC (1980). She has been made an honorary Doctor of Science by the Louisana State University, Baton Rouge (1986) and the University of Melbourne (1989). In 1991 ninety of the 200 watercolours done over ten years for Louisiana will be exhibited at Oxford, Cambridge and Edinburgh.

WALSH, Wendy (b. 1915) Although born in Westmorland at Bowness-on-Windermere, Wendy Walsh has lived for 32 years in Ireland, where she has designed postage stamps for the Republic and for the Gilbert Islands (now Kiribati) and provided illustrations for several works including *Native Dogs of Ireland*. Her most important publication is *An Irish Florilegium* (2 vols, 1983–88), with text by Charles Nelson, depicting wild and garden plants which have a special association with Ireland.

WEBSTER, Ann (b. 1930) Trained at Guildford School of Art in 1948-9, Ann Webster became a free-lance botanical artist providing illustrations for publications associated with Kew, such as *Hooker's Icones Plantarum*, *Curtis's Botanical Magazine*, and the *Flora of East Africa* and the Kew Series of handbooks, *British Trees and Shrubs* (1958), *British Wild Flowers* (1958), *British Ferns and Mosses* (1960), and *Garden Shrubs and Trees* (1960).

Acknowledgements

Figs 4, 5 Reproduced by courtesy of the Bentham-Moxon Trustees, Kew

Plate

1 © Mary Bates. Property of Mr and Mrs P. J. B. Woods
2 © Mary Bates. To be published in *The Kew Magazine*
3 © Marjorie Blamey
4 © Marjorie Blamey
5 © Marjorie Blamey
6 © Jill Coombs. Reproduced by kind permission of Mr and Mrs Woodall
7 © Jill Coombs. Reproduced by kind permission of Mr and Mrs J. Player
8 © Jill Coombs
9 © Barbara Everard Trust for Orchid Conservation
10 © Barbara Everard Trust for Orchid Conservation
11 © Barbara Everard Trust for Orchid Conservation
12 © Ann Farrer. Reproduced by kind permission of John Vaughan
13 © Ann Farrer. Reproduced by permission of The Royal Horticultural Society
14 © Ann Farrer. Reproduced by kind permission of Simon Nuttall
15 © Mark Fothergill. Reproduced by permission of Mr Robert Burle Marx, Laranjeiras, Rio de Janeiro
16 © Mark Fothergill
17 © Mark Fothergill
18 © Victoria Goaman
19 © Victoria Goaman
20 © Victoria Goaman
21 © Mary Grierson
22 © Mary Grierson
23 © Mary Grierson
24 © Mary Grierson
25 © Mary Grierson
26 © Mary Grierson
27 © Ariel Press. Acknowledgements to Ariel Press
28 © Ariel Press. Acknowledgements to Ariel Press
29 © Josephine Hague
30 © Christabel King
31 © Christabel King
32 © Christabel King
33 © Joanna Langhorne
34 © Joanna Langhorne. Collection John d'Arcy

Plate

35 © The Royal Horticultural Society. Reproduced by permission of The Royal Horticultural Society
36 © Nonesuch Expeditions Ltd. From Margaret Mee *In Search of Flowers of the Amazon Forests*
37 © Margaret Mee Trust
38 © Margaret Mee Trust
39 © Valerie Price. First reproduced in *The Plantsman*. Reproduced here by permission of Peter and Janet Miller, London
40 © Valerie Price
41 © Rodella Purves. Reproduced by permission of Jim and Liz McKay, Penicuik, Mid-Lothian
42 © Rodella Purves. Reproduced by permission of Sandy and Elizabeth Soutar, Greenock, Scotland
43 © Rodella Purves. Reproduced by permission of Dr Dennis and Betty Graham, Edinburgh
44 © Rodella Purves. Reproduced by permission of Carol Milne, Crammond, Edinburgh
45 © Pandora Sellars
46 © Pandora Sellars
47 © The British Museum (Natural History). Reproduced by courtesy of The British Museum (Natural History)
48 © Margaret Stones. Private Collection, USA
49 © Louisiana State University, Baton Rouge, USA
50 © The Royal Botanic Gardens, Kew
51 © Wendy Walsh. From W. F. Walsh and E. C. Nelson, *An Irish Florilegium II*, London, Thames & Hudson 1988
52 © Wendy Walsh. From W. F. Walsh, R. I. Ross and E. C. Nelson *An Irish Florilegium*, London, Thames & Hudson 1983
53 © Wendy Walsh. From W. F. Walsh and E. C. Nelson *An Irish Florilegium II*, London, Thames & Hudson 1988
54 © Eyre & Spottiswoode. Reprinted by permission of Eyre & Spottiswoode from *British Wild Flowers* 1958
55 © Eyre & Spottiswoode. Reprinted by permission of Eyre & Spottiswoode from *British Wild Flowers* 1958
56 © Eyre & Spottiswoode. Reprinted by permission of Eyre & Spottiswoode from *British Wild Flowers* 1958

Some sources of further information

ALLAN, M. 1967. *The Hookers of Kew, 1785–1911*. London.

ARBER, A. 1938. *Herbals, their Origin and Evolution*. 2nd edn. Cambridge [3rd edn 1986, with Arber's text unaltered but supplemented by W. T. Stearn].

BAER, W. & LACK, H. W. 1979. *Pflanzen auf Porzellan. Katalog*. Berlin.

BAUMANN, F. A. 1974. *Das Erbario Carrarese und die Bildtradition des Tractatus de Herbis*. Bern.

BLUNT, W. 1955. *The Art of botanical Illustration*. London.

BLUNT, W. & RAPHAEL, S. 1979. *The illustrated Herbal*. London.

BRIDSON, G. D. R. 1989. From xylography to holography: five centuries of natural history illustration. *Archives of Natural History* 16: 121–141.

BRIDSON, G. D. R. & WENDEL, D. W. 1986. *Printmaking in the Service of Botany. Catalogue of an Exhibition*. Pittsburgh.

BULTINGAIRE, L. 1928. Les peintres du Jardin du Roy au XVIIIe Siècle. *Archives du Muséum de l'Histoire Naturelle de Paris* VI 3: 19–36.

CALMANN, G. 1977. *Ehret, Flower Painter extraordinary: An illustrated Biography*. London.

COATS, A. M. 1974. *The Book of Flowers. Four Centuries of Flower Illustration*. 2nd edn. London.

COATS, A. M. 1975. *The Treasury of Flowers*. London.

CURWEN, H. 1947. *Processes of graphic Reproduction in Printing*. 2nd edn. London.

DANIELS, G. S. 1974. *Artists from the Royal Botanic Gardens, Kew*. Pittsburgh.

DESMOND, R. 1987. *A Celebration of Flowers. Two Hundred Years of Curtis's Botanical Magazine*. Kew & Twickenham.

DIMENT, J. W. & OTHERS. 1984. Catalogue of the natural history drawings commissioned by Joseph Banks on the *Endeavour* voyage. Part 1; Botany: Australia. *Bulletin of British Museum (Natural History), Historical Series* 11: 1–183.

GERSTENBERG, K. 1936. *Albrecht Dürer: Blumen und Tiere*. Berlin.

EMBODEN, W. A. 1987. *Leonardo da Vinci on Plants and Gardens*. Bromley, Kent.

HAIRS, M.-L. 1965. *Les Peintres flammands de Fleurs au XVIIe Siècle*. Paris etc.

HARDOIN-FUGIER, E. & GRAFE, E. 1989. *French Flower Painters of the 19th Century*. London.

HEMSLEY, W. B. 1915. Walter Hood Fitch, botanical artist, 1817–1892. *Kew Bulletin* 1915, 277–284, 392.

HERDEG, W. (ed.) 1973. *The Artist in the Service of Science*. Zürich.

HULTON, P. & SMITH, L. 1979. *Flowers in Art east and west*. London.

JACKSON, B. D. 1905. The history of botanic illustration. *Transactions of Hertfordshire Natural History Society* XII. 4: 145–156.

JACKSON, B. D. 1924. Botanical illustration from the invention of printing to the present day. *Journal of Royal Horticultural Society* 49: 167–177.

Lack, E. & Lack, H. W. 1985. *Botanik und Gartenbau in Prachtwerken.* Berlin & Hamburg.

Lack, H. W. 1987. *100 botanische Juwelen, 100 botanical Jewels.* Berlin.

Mabey, R. 1988. *The Flowering of Kew. 350 Years of Flower Paintings.* London.

Mee, M. 1988. *In Search of the Flowers of the Amazon Forests.* Woodbridge (Suffolk).

Mitchell, P. 1973. *European Flower Painters.* London.

Nissen, C. 1966. *Die botanische Buchillustration: ihre Geschichte und Bibliographie.* 2nd edn. Stuttgart.

Pächt, O. 1950. Early Italian nature studies and the calendar landscape. *Journal of the Warburg and Courtauld Institutes* 13: 13–47.

Opsomer, C. & Stearn, W. T. 1984. *Livre des Simples medecines. Codex Bruxellensis IV. 1024. A 15th-century French Herbal.* 2 vols. Antwerp.

Rix, M. 1981. *The Art of the Botanist.* Guildford & London.

Ross-Craig, S. 1953. Botanical illustration. *Medical & Biological Illustration* 3: 8–19.

Rytz, W. 1935. Das Herbarium Felix Platters. Ein Beitrag zur Geschichte der Botanik des XVI Jahrhunderts. *Verhandlungen der Naturforschenden Gesellschaft in Basel* 44: 1–222.

Rytz, W. 1936. *Pflanzenaquarelle des Hans Weiditz aus dem Jahre 1529.* Bern.

Seybold, S. 1986. *Die Orchideen des Leonhart Fuchs.* Tübingen.

Singer, C. 1927. The herbal in antiquity and its transmission to later ages. *Journal of Hellenic Studies* 47: 1–52.

Slythe, R. M. 1970. *The Art of Illustration, 1750–1900.* London.

Stafleu, F. A. & Cowan, R. S. 1976–1988. *Taxonomic Literature.* 7 vols. Utrecht.

Stearn, W. T. 1954. Codex Aniciae Julianae, the earliest illustrated herbal. *Graphis* 10: 322–329.

Stearn, W. T. 1964. The self-taught botanists who saved the Kew Botanic Garden. *Taxon* 14: 293–298.

Stearn, W. T. 1979. The historical background to the illustrations of the *Herbarium Apulei* and *Herbolario volgare.* Prefixed to Edizioni Il Polifilo facsimile of *Herbolario volgare* (as pp. xliii–lxxi). Milan.

Stearn, W. T. & Rix, M. 1987. *Redouté's Fairest Flowers.* London.

Stiff, R. L. A. 1988. *Flowers from the Royal Gardens of Kew; two Centuries of Curtis's Botanical Magazine.* Hanover, N. H., & London.

Sydney, C. 1986. *Flower Painting.* Oxford.

Wellmann, M. 1897. Krateuas. *Abhandlungen der Königlichen Gesellschaft der Wissenschaften zu Göttingen, Philologisch-Historische Klasse* N.F.2: 1–32.

West, K. 1983. *How to draw Plants. The Techniques of botanical Illustration.* London.

Index of plants by botanical families